living ARtfuLLy

Create the Life
You Imagine

Sandra Magsamen

FREE PRESS New York • London • Toronto • Sydney

I dedicate this book to the small acts of living,
where the greatest joy is found.

FREE PRESS
A Division of Simon & Schuster, Inc.
1230 Avenue of the Americas
New York, NY 10020

For information about special discounts for bulk purchases,
please contact Simon & Schuster Special Sales at
1-800-456-6798 or business@simonandschuster.com

Designed by Dana Sloan
Illustrations by Sandra Magsamen

Manufactured in the United States of America

1 3 5 7 9 10 8 6 4 2

Library of Congress Cataloging-in-Publication Data
Magsamen, Sandra.
Living artfully : create the life you imagine / Sandra Magsamen.
p. cm.
1. Creative ability. 2. Life. 3. Quality of life. I. Title.

BF408.M224 2006
158 dc22 2006040556

ISBN-13: 978-0-7432-9105-7
ISBN-10: 0-7432-9105-0

Contents

the art of Living

Denise was about to celebrate her fiftieth birthday, and all she really wanted was to get to know her family better. Over the years, they had moved away from each other, raised families, built lives—but they had also drifted apart. Even when they did get together on holidays, they ended up telling the same old stories over and over again. This time, Denise decided to get creative.

She invited her parents, brothers, sisters, in-laws, nieces, and nephews to a restaurant for the big birthday dinner. Before anyone arrived, she placed a small papier-mâché box with a cake painted on its lid at each seat around the table. Inside every box were twenty-five little slips of paper, each bearing a different question. Who would play you in the movie of your life? What is the kindest thing anyone has

ever done for you? What is your greatest strength? If you could do one thing over in your life, what would it be? Whom would you most like to meet? What are the three words you'd want other people to use to describe you?

One at a time, the guests (including Denise) opened their boxes, pulled out a question, and answered it. The night was filled with laughter, joy, and even a few tears. Although the restaurant was wonderful, no one remembers the food. But everyone has memories of stories told and the gift of themselves they shared. The evening celebrated one birthday and the rebirth of many friendships as well as family closeness. Denise felt that her reconnection to the people she loves was the greatest birthday present she could have received.

That's Living Artfully.

Recently, I was in the audience for a talk given by Mariane Pearl, author and widow of Daniel Pearl, the *Wall Street Journal* war correspondent who was kidnapped and murdered in 2002 by terrorists in Pakistan. She told us about the amazing outpouring of love and hope she received from people all over the world after the heartbreaking vigil that ended with the news of Danny's brutal killing. In particular she spoke of a gift that came for her infant son, Adam, from a woman in Austin, Texas. Mariane read from the letter that accompanied it, which she also included in her book, *A Mighty Heart.*

"Dear Mariane," it began. "Please accept my gift of a quilt for your son. I was deeply touched by your tragedy and wanted to do something for you." Though she was a stranger, and not in a position to help Mariane in person, she was a quilt maker and, as she put it, "nothing says love, in my mind's eye, like a quilt." She went on to say, "Hopefully the quilt will bring you both pleasure, security, and a bit of comfort. That is my wish."

That's Living Artfully, too.

Each of us wants to connect more closely with the people in our lives. We want to know that we belong, that we are loved, and we want to make others feel the same way, too. We want to do something that matters for them and something that is also meaningful to us. Each of us also has a basic human need to create. The desire to make beautiful, meaningful moments and things is an undeniable part of us. It's in our spirits. This book celebrates the creative ways we connect with each other—the ways we live artfully.

Life is a work of art and we are its artists, born with the tools—our innate imagination, curiosity, and playfulness—to create anything we can imagine. Living Artfully is expressing who you are through these objects and moments that you create. To live artfully is to live life fully, with meaning and a purpose—to bring beauty into being.

I define art in the broadest sense—it is every possible medium of human expression. It is in what you say and how you say it. Art is simply the name for how you live your life and how you tell others what you think and feel.

We all make choices every moment of every day, from how we fill our hours to how we decorate our homes to which gifts we will share with the people in our lives. Living Artfully reminds us to expand the possibilities of how we do all these things. It asks us to imagine, to dream big, to believe in ourselves and celebrate the people in our lives, to make each day count, dance when the spirit moves you, laugh out loud, and let your voice be heard. It reaffirms our belief that every human being is a beautiful, unique work in progress.

"The more I think, the more I feel that there is nothing more truly artistic than to love people." Vincent van Gogh said that in the 1800s, and that timeless truth is just as profound today.

Living Artfully is a call to reawaken your creative spirit. It is your personal call to action. It is also your personal call to pleasure.

I want to spark a personal renaissance within you—whether you're a man or a woman, and no matter what your age. I want to inspire you to create the life you imagine: to create something with your hands, create a garden that exudes beauty, create love, create a home that nurtures yourself and your family, create a memory, create a quilt to cover someone

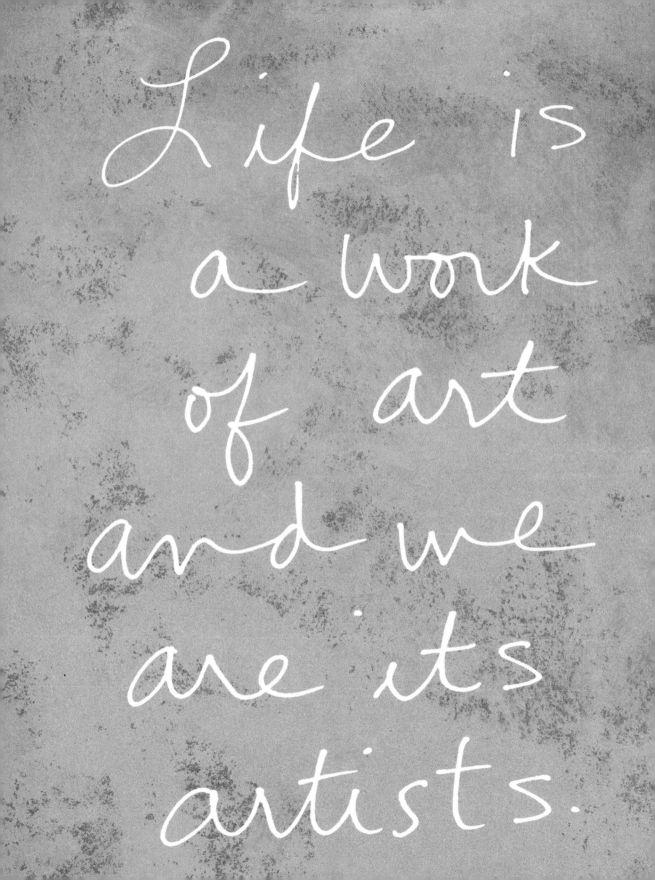

Life is a work of art and we are its artists.

"The more I think, the more I feel that there is nothing more truly artistic than to love people."

Vincent van Gogh

with tenderness, create a moment, create yourself, create a friendship, create an experience you will never forget. I want you to see that you *can* create because you *must*.

Living Artfully is a force that can transform your life and how you view your role in life. As it shifts your perception—once you begin to see the possibility of art in everyday things and moments—you will never look at life the same way again.

From the moment we're born, we find ways to express what we feel. Babies babble, laugh, cry, and instinctively manage to communicate to the rest of us. As we grow, we learn new ways to express ourselves, some complex, others quite simple.

Ironically, as innate as our desire for self-expression is, we often edit ourselves—we hold back, we censor our thoughts and desires. It's not that we don't want to connect and communicate; sometimes we just don't know how. Living Artfully will put you back in touch with what you feel and what you want to say, ultimately helping you to discover your own special, unique gifts for doing just that. Living Artfully recognizes and celebrates the many amazingly innovative and imaginative ways we express who we are and what matters most to us.

If you are already Living Artfully, let this book reaffirm and validate your individuality and your desire for creative self-expression. Let it expose you to exciting new ways to deepen and broaden your involvement in life and communicate what's in your heart.

Even if you haven't yet found your creative outlet—or didn't realize that you lacked one—*Living Artfully* will reach out to you, too. Folks who steer clear of Living Artfully have usually been intimidated, made to doubt themselves by that noisy, little inner critic that says, "I can't do it right" or "What will people think?" I run into this emotional hurdle all the time in the people I meet. The other day I was in the airport, my bag filled with art supplies for a TV show taping. The security guards flagged my bag and a woman attendant asked if she could open it. "Sure thing," I said, and she proceeded to remove beaded ceramic plaques, handmade books, ribbons, and hand-painted cards from the bag, until she uncovered the needle-nose pliers buried at the bottom.

"I always wanted to take up beading," she said. "In fact, I even bought the beads and a book. But I was afraid to try it."

"What scared you?" I asked.

"Oh, I was just afraid that I wouldn't do it right."

"What if you just did it your own way?" I said. "No rules, no right or wrong, just what you think is beautiful?"

She held the pliers and looked at me for what felt like a long time. "I never thought about it that way," she said.

I find myself saying this again and again: there are *no* rules, just that you be you, the only you there is. In a world where you are told you can be anything, just be yourself. Do what you think is beautiful. I'm kind of evangelical about this particular point. If you worry about what others might be thinking or saying, do something that will really make them talk—*have fun!* It's contagious! As adults we must consciously go against the grain of our "grown-up" programming. We have to give ourselves permission to play, to dream. Part of Living Artfully is to play, invent, laugh, envision, and have fun as you celebrate the people and moments that make life wonderful. This book will remind and encourage you to do that.

I am a great believer in the power of art and creativity. Living Artfully reconnects and reaffirms your ability to gain access to your personal power and use it. When you connect your inner feelings with a personal act that expresses love, or kindness, or concern, you are affecting the world in a powerful and significant way. As you reacquaint yourself with the innate creative gifts that you possess, you'll never again allow self-doubt and intimidation to stop you from doing artful things. A dad I know packs a silly joke in his daughter's lunch box every day. A babysitter arranges after-school snacks on the plate to look like happy faces. A beloved grandfather keeps a "building corner" stocked with pieces of wood, glue, and cardboard scraps so his grandchildren can create cities, spaceships, boats, or bridges when they visit.

Every time I define Living Artfully to a friend, coworker, or women attending a workshop or seminar, a wonderful thing happens and I hear comments like:

Hey, I did something like that. I hosted a bridal shower for my best friend and asked all the guests to create a page for a cookbook as a gift for the bride-to-be. Each guest

designed a page that shared ingredients and directions for cooking a delicious dish, also with added tidbits of advice on making a loving and lasting marriage. I put all the pages in a book and titled it Cooking Up Love. *My friend adores it and we had so much fun making it.*

Or,

That's like what I used to do for my two sons. During elementary school, I'd pack their lunches every day and I'd always put a banana in each bag. One day I started writing little notes—jokes and riddles on the banana peel with a permanent pen. The boys loved it and looked forward to their lunchtime surprise. I loved it, too, knowing that as I was thinking about them at lunchtime, they would be thinking of me. Of course, by middle school, they asked me to stop sending notes on their bananas. They were "too old." The boys really did get a kick out of it, but it never occurred to me that I was being artistic!

As you read *Living Artfully,* I hope that your own definition of creativity will blossom and expand. Creativity is not about being a Michelangelo. It lies in discovering your own way of sharing. It's tucking a chocolate kiss into a husband's jacket pocket, sharing the first rose of summer, drawing faces on a steamed-up window with a child, or baking an unexpected, extra-large thank-you cookie for a friend.

I'm willing to bet that as you read, you will be amazed by how creative you already are—how many simple, beautiful things you do naturally that add that extra something special to your life and the lives of the people you love. You just haven't been conditioned to think of these things as being important, so it's not surprising to me that you might not recognize your creative talents. But even if you do, I'm also willing to bet that you want more. More ideas. More inspiration. More meaning. Living Artfully can give you that. On a basic level, Living Artfully can give you a physical way to connect with the planet and the people you love.

Each of us

more closely

in our lives.

know that we

loved, and we

others feel the

wants to connect
with the people
We want to
belong and are
want to make
same way, too.

The desire to make beautiful, meaningful moments and things is an undeniable part of who we are.

With Living Artfully, I am putting a name to something you may already be doing. And by identifying it and bringing more awareness to the importance of these little (and sometimes big) creative endeavors, I'm honoring you, the artist, so that you can embrace your artistic nature with greater enthusiasm. This book differs from being a "craft" book or another how-to book, self-help book, or cookbook. There are mountains of good books offering instructions, must-do's, how-to's, and rules to follow. Ahead, you'll find answers to the why-do's as well as meaningful, inspirational, and unique stories of the infinite ways people are living the life they imagine. Living Artfully is about creating a life worth celebrating, worth remembering.

As you'll see, my philosophy is that the process of creation is far more important than the product. You'll notice that in this book's title, the word *living* comes *first*. To me, the biggest joy in creating things is how we use them to have fun while expressing ourselves to those we love. *Living* because we are engaged in making a life, and *artfully* because we do so with unbridled creativity, authenticity, and heart. In the end, that's what all those scrapbooks and hand-crocheted scarves and made-from-scratch birthday cakes really are—they're like bridges connecting us to one another. They're messages from our hearts, messages of encouragement, hope, laughter, and kindness. They lift the spirits of those around you and refresh your own sense of self. Of course we want the things and moments we make to be beautiful, but we should also see them as a means to a beautiful end—an expression of ourselves, of what we feel, and of what we feel for others. That's why it's important to keep in mind that our creations don't have to be perfect. They're actually better when they're not. What counts is that it—whatever form *it* takes—comes straight from the heart.

As you start Living Artfully—or return to Living Artfully—be gentle with yourself. We have been conditioned to focus on whatever little thing isn't quite right about ourselves, our creations, and our surroundings. Instead, let's decide to focus on what is right, lovely, and beautiful. This is a simple concept, yes, but it's transformative just the same. Many people today have been looking outside themselves for well-being and happiness when what they've been searching for has been inside them all along. It's inside us, inside you and me. Just turn your eyes inward and you'll see it.

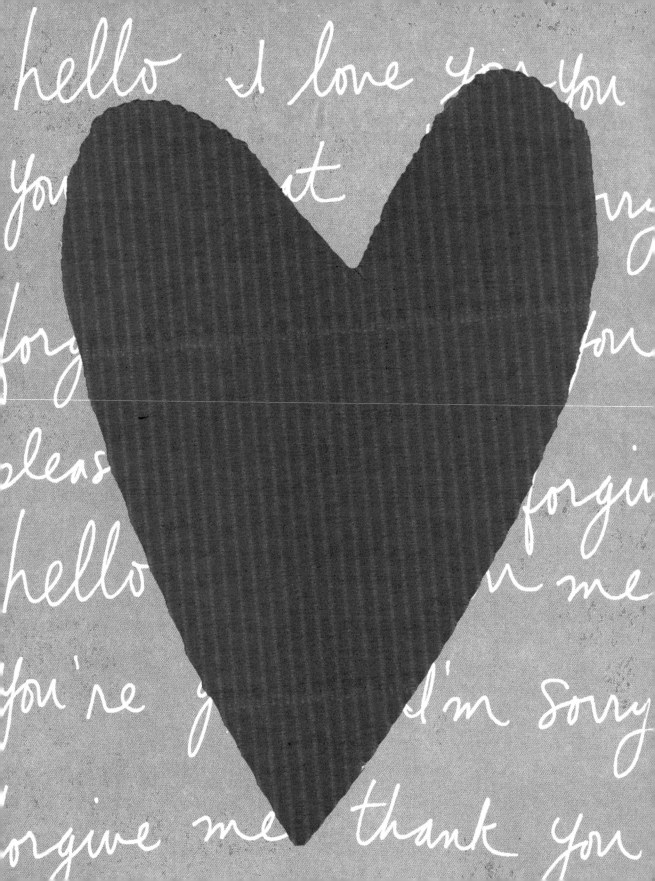

messages from the heArt

Making Connections

The messages contained in our hearts are universal. Regardless of how old we are or the language we speak, we all wish to say the same basic things: "Thank you," "You're great," "You have made a difference in my life," "I'm proud of you," "I understand," "I'm sorry," "I love you," "Good-bye." With these simple, powerful words, we build the intimate and meaningful relationships that give us purpose.

A man from Vermont got into the habit of leaving his wife little notes. Nothing elaborate, just sweet sentiments like "I love you" or "I can't wait to get home to you tonight," jotted down on Post-it notes and then hidden in places where he knew she'd discover them during the day. She'd open a drawer and find a note, reach into a kitchen cabinet and see one, and so on. They were everywhere—from inside the dog food bin, to the laundry hamper, to the driver's seat of her car.

He was in the military and shipped out during the early days of the war in Iraq, where he was killed in action. On the morning of the funeral, his young widow put on her winter coat, placed her hands in the pockets, and found the last two notes, which he had hidden there for her as he left home. She pulled them out of her pockets, knowing exactly what they were. The first one read "I will always love you." And the other, "We will always be together." Did he know the circumstances under which she'd find them? It's hard to say. You can imagine the sorrow she felt as she read them, but think how lucky she is to have had a husband who managed to reach out with a final, loving gesture.

We can live artfully through a thousand little everyday gestures, as well as a multitude of creative pastimes. I define art in the broadest sense—it is every possible medium of human expression. It is in what you say and how you say it. It is in using the rich resources of your senses to connect with the beauty in life. The art is in the message and in the medium you use to express it. Art is simply the name for how you live your life and how you tell others what you think and feel.

My current life began after my daughter, Hannah, was born. I wanted to do something

special in our nursery, so I started making little clay plaques with messages on them. I thought that if I surrounded her with wise, loving thoughts and the things that I believed in, they would somehow sink in and make a difference in her life. Not only were these messages lessons for my daughter, but they also served as a gentle reminder to me of the simple truths I strived to embrace. I made ceramic plaques and inscribed them with sayings such as "Believe in yourself," "Let your dreams take flight," and "Follow your heart." I'd then add beading and paint, then fire them and hang them on the walls. They were fun to make, and the results were beautiful and made me proud. I had no way of knowing that this was the beginning of connecting with not only my daughter, but a great many people, most of whom I would never even meet. I can't say if my infant daughter was absorbing the literal meanings of the plaques, but I was, and in time she would, too.

I have four sisters and we're all close, and of course they spent a lot of time at our house when Hannah was a baby. My sisters would see the plaques and before long they began asking if they could have a few to give to their friends as gifts. They would just take the plaques right down off the walls, and I was flattered and made more to replace the ones they took. Soon I started hearing from their friends who had received the plaques as gifts and wanted to buy more to give away to their friends and family.

So, down there in our basement, my art business was born. I bought a little kiln and put it where the clothes dryer was supposed to go, and I started making and selling plaques. I like to say that I stopped doing laundry and started doing pottery. I was working full-time as an art therapist then, but little by little the pottery began taking over my life. I realized that the plaques were really just another form of art therapy (or a continued way to avoid laundry)—people wanted to express feelings that they couldn't fully communicate themselves. I branched out to art fairs, and before long I was selling to gift shops, and from that it turned into a thriving business with fifteen employees operating out of a converted barn in Maryland (and a dryer in my laundry room).

People ask me, "Sandra, how do you come up with all the ideas and expressions?" I hate to disappoint them, but I always point out that the expressions are so basic, and so much a part of people's emotional lives, that I don't really have to invent them. I am con-

There is
no end
to the ways
in which
we can share
what's in
our hearts.

stantly finding new phrases just by listening to people, even strangers. Recently I was in an airport bathroom when I heard a woman say on her cell phone, "Don't worry, honey, our life may have some dips, but together we'll get through them." I had to jot it down on a paper towel before I got out of there. On the train I overheard a young man speaking with clear abandon on his cell phone, declaring, "Life's just better when we're together." Out of necessity (okay, joy), I have become a professional eavesdropper. Or I'll read something in a magazine or a novel and add it to my notebook. The power of any expression lies in its emotional truth, so you don't have to get too fancy to capture the most important feelings.

As these clay messages spread across the country, so did the distance over which the letters, e-mails, and stories would come, revealing how people were experiencing them, sharing them, and connecting with others in artful ways.

Not long ago, I heard from a mother and daughter who had gone to a store that carries my plaques after the daughter learned that she had advanced breast cancer. She said, "Mom, I want to pick out some messages for certain people, and when I'm in hospice care and can't speak for myself, I want you to give them their plaques." She chose a bunch, and then she picked the one that would go to her mother. It read, "You are the best mother in the whole universe."

When I heard that story, I was awed by the fact that these little ceramic messages could be given as such a big, heartfelt legacy, and I was touched that I had made something that could matter so much—that could give a dying daughter some peace. Sharing these simple truths had seemed so easy; their strength had been somewhat imperceptible to me until that moment. Hanging them on my infant daughter's walls was one thing, but having them connect the worlds between life and death was beyond anything I had considered.

A friend recently shared another truly beautiful story with me of a creative gift a mother who was dying of cancer gave to her seven-year-old daughter. She envisioned all of the future milestones she would miss in her daughter's life—birthdays, graduations, her wedding day, the birth of her children—and she wrote letters to her daughter to read for each of them. The idea was that the letters would be given to the daughter throughout

her life from the most special woman in her life—her mother. Although she was physically having to say good-bye, this devoted mom was ensuring that she'd continue to live in her daughter's life through these precious expressions of love.

There is no end to the ways in which we can share what's in our hearts. Still another story of artful living is this sweet example of a family that created a book entitled *Love Is.* This beautiful book was created to celebrate a forty-fifth wedding anniversary. The children and grandchildren of the "lovebirds" each thoughtfully described the lessons they'd learned about love from their mother and father (or grandmother and grandfather). Each one begins "Love is": followed by the lesson: "By always welcoming us into your home with open arms and hearts you have taught us how to be generous." And "The cute nicknames you have given us, like Kissa Marysa, shows how much you love us." And "Giving us lots of hugs and kisses." And "When you share your sand castle, pool, beach, toys, snacks, and chocolate with us." And my favorite, "To say 'I love you' more often than not, and always before saying 'good-bye.'"

Whether you recognize it or not, you have always included some form of artfulness in your day-to-day living. But there are three good reasons why Living Artfully is particularly important today.

Living Artfully is important because we all hunger for more self-expression.
I don't mean that we fail to speak our hearts (although that's probably true in many cases). I mean that deep inside, we all yearn to create things and moments that make our feelings tangible. We want to convey more than what spoken words alone can say. Sometimes there simply are no words to express what we're feeling. Sometimes a gesture of kindness says it all. And yet, these days, not enough of us heed—or even acknowledge—this desire to create.

Everyone in my studio knew and loved Jean, who used to answer the phones a few days a week. So when she was diagnosed with lung cancer, we were all saddened and concerned. The days Jean went in for treatments were very difficult for her—she was so scared of the hospital, the needles, the chemotherapy, and of course the cancer itself. Not knowing what

to do, but wanting to let her know we cared, I asked everyone in the studio to make something we could put into a box that might bring a smile to Jean's face or give her a moment's peace—a "box of hope." The studio assistants and I filled the box with quotations, drawings, cartoons, life-affirming messages, jokes, and thoughts that might occupy her mind during the treatments. The number of things we packed into that box was amazing. Everyone wanted to help. We decorated it and Jean took the box with her on every visit.

Later, she told us how much she loved the box and looked forward to opening it each time to discover what was inside. Her treatments were still frightening, but now they were also punctuated with many moments of inspiration, love, and kindness. Jean found strength, hope, humor, and joy hidden within the box and herself.

The second reason Living Artfully is important is because many people feel a lack of meaning in the work we do all day. Today, most people I know go through life at top speed. Women in particular are insanely busy, whether working in the home or out of it. On any given day they perform a mind-boggling number of tasks, but they often feel as though they haven't accomplished very much. They're running so fast that their life has become a blur, but when they do stop for a second to look around, they're disappointed by what they see. They wonder just what it is that they're devoting so much of themselves to, and if it's worth it. They say they want to slow down, do things that feel more meaningful. And they want to do things well—not at breakneck speed, and not slapdash because there's no time or energy to do them any better. In this fast-paced world, we seem less able to focus and see the things that really matter.

Many Americans spend the bulk of their waking hours getting ready for, going to, sitting at, coming home from, and winding down from work. When we're not busy performing our jobs, we're thinking of work or trying to recover from it. Yet even for those of us who love our chosen work, we want the efforts of our hands and our minds to yield something more meaningful than making ends meet or accumulating money. Despite our exhaustion and jam-packed schedules, we want to put more of ourselves into our lives and into the world. We know there *must* be a way, but modern life often erodes the connection between

us and our labors. We are distanced from our innate creativity and don't want the idea of "getting creative" to be just another "to-do" entry on our endless list.

The simple truth is that each one of us has the power to make the world a better place. We each leave our mark on the world every moment of every day through the choices we make and the actions we take.

Living Artfully is important because we need more opportunities for *play!* We need more fun, more imagining, more well-being. We need more of the sensation of being lost in a moment of joy. We knew that feeling each day in childhood but, for the most part, not since—even though we are all still the same human beings, with the same basic emotional needs, as we were back then.

When I was a child my mom would send my four sisters and me out to play on summer days. "Don't come back until dinner" were her parting words as she ushered us out the door. We spent our days discovering and creating big adventures, building forts, riding bikes, jumping rope, singing silly songs, chasing butterflies, hiding in cornfields, picking flowers, making mud pies. We used our imagination, we played, we created, we found wonder in everything, and we discovered, experimented, invented, laughed, felt accomplishment, and lived in the moment. I loved those unstructured, carefree days where everything about life and being me was filled with possibility.

Play rejuvenates and revitalizes us. It helps us see the world from different points of view. It rekindles our optimism, encourages experimentation, and renews our ability to be flexible and make meaningful connections as we continually adapt to our changing world. One of the most wonderful by-products of play is laughter.

Laughter is inner jogging.
—Norman Cousins

We each leave our mark on the world every moment of every day through the choices we make and the actions we take.

Research shows that laughter lowers blood pressure, reduces the release of stress-related hormones, increases muscle flexibility, and boosts immune function. Laughter also triggers the release of endorphins, our body's natural painkillers, and results in a general sense of well-being. Laughter is an instant vacation; it's also a lifesaver.

Living Artfully will encourage and inspire you to reconnect with your enthusiasm and your passion. Play will again become a joyful part of each day; even simple chores like cleaning the house can be filled with fun. I know a mom with four teenagers still living at home who was tired of complaining about the never-ending river of clothes spilling out from her small laundry room into the hallway. So she got creative. Now every Sunday, each family member washes and dries one or two loads, and then they all gather together in the TV room with popcorn and a movie for a family "fold-a-thon." Another woman I know turns up her stereo as loud as she can on Saturday mornings before proceeding to dance her way through vacuuming the house to the blaring, soulful sounds of Aretha Franklin. Tell me she isn't giving herself some R-E-S-P-E-C-T!

ake-believe and play go hand in hand, and too many grown-ups forget how much fun it is to use their imaginations playfully. When I was a little girl, every day after school my neighbor and I made believe we were famous chefs. My favorite food back then was pizza, so we invented little superspecial, secret-sauce replications of what we'd seen thrown together down at the local pizzeria. We mixed together the perfect amount of ketchup, garlic, oregano, and salt and pepper for a surprisingly delicious sauce, slathered it on an English muffin, and topped it with the essential ingredients. Our tasty mini pizza pie rivaled anything made by the pros—at least in our minds!

Thirty years later, after I read *Under the Tuscan Sun*—a captivating book about an American woman's soulful, life-changing adventure moving into and refurbishing an aging villa in Tuscany, Italy—I wanted so badly to pick up and travel to the Italian countryside to experience all that I had read, but that wasn't possible. So I reactivated my make-

believe skills and, for an entire summer, acted "as if" I were a fresh transplant in my new home away from home—Italia! My physical body was living responsibly in Maryland, but my mind and heart were otherwise happily Italian.

Over the course of several months, I learned to make all sorts of pastas and bruschettas, and immersed myself in the historical "stories" behind the recipes when I could find them. I discovered (and drank a few glasses of) Italian wines—the point was having fun, no?—while the aroma of roasting garlic and simmering tomato-basil sauce wafted beyond my home and into the surrounding neighborhood. I visited local vineyards to continue my Italian-style reverie. Friends and family asked me about my sudden interest in opera and Italian films, and enjoyed the adventure I provided in the many Italian meals I cooked and wines I served. My journey became their journey, too, and all of our lives were enriched. We weren't anywhere near Europe, but it was great fun just the same!

 am convinced that even if Mozart had been a mediocre musician, he would have composed and performed with passion. Had Grandma Moses been a lousy painter, she still would have been driven to express herself in pictures. Artists and authors don't create just because somebody tells them they should, or because they receive stellar reviews. Something inside makes them do it. The novelist Don DeLillo has a great line: "I write so that I can know what I'm thinking." In this way, these gifted few are exactly like the rest of us: they wish to express themselves through acts of creation, and they feel better—more alive, more in touch with themselves and the world—when they do so.

A concerto is a cake is a sculpture is a scrapbook is a sonnet is a sweater. There is no difference between the human impulses behind one act of creation and another. The distinctions between "good" and "bad" quality or "high" and "low" art don't really exist. There's only creation, and the joy that comes with it. We've all become indoctrinated into thinking that only the artist has the right to create. But you don't need a special license or a

diploma hanging on your wall in order to express yourself. This artificial divide between artists and the rest of us may have always existed, to an extent, but I feel that it has gotten bigger in recent years—and at a cost. It hurts us as individuals and as a society when this misperception intimidates us into silence.

In spite of this, however, millions of people today are reaching for creative outlets. All over the country, groups of women are assembling to crochet and knit together, to quilt, read, kick back, let their hair down (or pull it up so they can get down to business), talk, and just be. There are women meeting each week to make music, create scrapbooks, start a business, cook meals, and build community gardens. Still others gather to sew blankets for children in pediatric AIDS programs, galvanize town folk to raise funds for literacy classes at the local library, or build a new playground at the neighborhood park. Some gather to indulge their creative spirit because it is fun and highly social, some because they need a deeper sense of community and the chance to really connect with their fellow human beings. These women and men—you and I—are making history. No one's given this movement a name. I call it Living Artfully.

These people are serious knitters, scrapbookers, quilters, musicians, cooking-channel aficionados, entrepreneurs, and volunteers—and they bring the same kind of ambition and high standards to baking, crocheting, inventing, organizing photos, playing music, sewing, and volunteering that they apply to their work. This creative subculture is still just beneath the radar, but it is growing like wildflowers.

There are good reasons why this strong creative force is on the rise today, and they have a lot to do with how our lives have changed over the past forty or fifty years. Some of the change has been technological—laborsaving devices have taken away some of the household jobs we once did as a matter of course. But it turns out that those tasks were more than merely necessary; they were also labors of love that improved our families' lives. Doing them well, with care and mindfulness, added meaning to our human experience.

The biggest transformation, though, has been social—women joining the workforce. Women who went to college in the sixties and seventies especially were taught to value career achievement and income over the traditional appeals of home life. Not that we're

complaining, since I and most of the women I know have benefited from the freedom to choose the goals we pursue.

But it hasn't all been for the better. Once we valued ourselves (and society valued us) for how well we managed the domestic arts—not just the drudgery end, like cleaning and laundry, but also how well we baked and cooked, how beautifully we decorated our homes, how graciously we entertained, and how much care we lavished on our children and our husbands. We did all these things not because they seemed like cool hobbies, but because they were necessary and we contributed to the family's financial health by doing them. As a result, we were closely connected to the trappings of our lives. They made us proud. They satisfied us in some deep, even spiritual place.

There's no doubt that we can find great pleasure in working in careers making contributions that way. But we may not experience a deeper sense of meaning from those jobs. Living Artfully can give you that. On a basic level, Living Artfully can give you a physical way to connect with the planet and the people you love.

Knitting, for example, brings order to chaos. The repetitive action of casting the yarn is soothing and meditative. And you end up with something that wraps you or someone you love in warmth. In scrapbooking, you gather together the pieces of your life and assemble them in a way that shows what matters most. When you put on paper the images of those you hold most dear, you honor them in a way that will last for generations. The book becomes a treasure—a family heirloom.

Cooking is much the same. When we cook for someone, we're nurturing his or her spirit and body. It's a way for us to take care of each other, emotionally and physically. If you think about it, the gift of food is literally a gift that sustains life. And in many ways you're saying that life's delicious. We all have our favorite comfort food that Mom or Grandma or a kind neighbor used to make. Sure, it tastes fantastic, but after a while, it's not so much about the food as it is the love *behind* the food that brings a smile to our faces. It's the memories of joy and sharing and caring that give the ritual its significance.

Music can also lift and soothe our spirits. It can call us to get up and dance, to sing, and to jump around while making joyful noises. Perhaps you've heard about the Mama-

palooza festival—a musical movement started in 2001 when a forty-seven-year-old mother with four kids nearly died of lupus and a kidney transplant. Believing in the healing properties of music, she gathered together a group of suburban homemakers who all loved making music, but who had stopped playing because they had become mothers and responsibilities like carpools and doing laundry had taken center stage in their lives. Several friends of the founder, Joy Rose, formed a band and played at a few parties. Another group of moms heard about it and did the same, and then another. Now it's a cultural "Moms Who Rock" movement, inspiring mom-bands all over the country. Joy says, "I wasn't trying to find the art in my surroundings, but the art in myself."

Do you remember when people used to make their own music? This isn't ancient history I'm talking about. People used to play musical instruments in their homes, among friends and family. They weren't all virtuosos, and they didn't want to be. They were insurance salespeople and truck drivers and teachers and retirees who also just happened to be people who loved to make music. Anytime was the right time to dust off the piano or break out the banjo and play. Everybody else would sing along. They didn't sing and play for money or glory—they sang because it felt good. Because it brought everybody together for an hour of fun and companionship, and yes, creative expression. They were Living Artfully.

At one time people actively participated in all sorts of creative activities. Now, too often, creation has become a spectator sport. I want to change that. And I want you to change it in your life by acting on your own innate impulses to be creative.

In traditional cultures, art was an integral part of life; it wasn't kept separate from daily activities. In fact, there was not always even a word for art. Objects were created in the service of living, not to hang in museums. Utensils were carved or forged for use in farming and cooking, fabric was woven for warmth, pottery was crafted for serving and storing food, and stories were told to pass on history, values, and ideas. Art was woven into the fabric of everyday life, not to be defined as good or bad, and so it was personal; it was authentic. If your grandmother and mother made quilts, for example, it was probably because the family needed them. Making them with your own two hands for loved ones to

use was meaningful in a way that working in a high-powered job and earning enough to buy a thousand-dollar comforter is not.

magination, play, and creativity have been a kind of personal salvation for me. Thoughout my life, people, moments, events, and challenges unknowingly collaborated to introduce me to the innate beauty in life and teach me to live artfully. While this book is meant to emphasize *your* life, not mine, we can connect to one another through sharing our personal stories. When linked together, our life stories create our world. So I will offer you some of the experiences that have nurtured, inspired, and motivated me. From them, you might see where and how your own story is guiding you to live artfully. Creativity has enriched my life and I believe wholeheartedly that it can have a similar effect on yours.

When I was twelve, I was injured while helping my dad clear some rocks from a field. A piece of heavy farm equipment fell on me, causing a compound fracture of my left leg. My father was desperate to free my leg, but the equipment wouldn't budge for him. I yelled for my twin sister, and she effortlessly and miraculously lifted the equipment off of me. I spent the better part of a year healing, first in the hospital and then at home. I attended a home and hospital school where I spent many hours on a headset over the phone, connecting with children—other students who were either injured (often having been in terrible car accidents) or fighting battles with life-threatening cancer.

Expressing myself verbally didn't come naturally. I was a shy child, not terribly talkative. That was partly because I have a twin sister, and she and I communicated with a minimum of words. But it was also just my nature. Words alone seemed to fail me.

Bonding with new people and forming connections outside of my regular school were important lessons for me. Because I could not see these children, in my mind I painted pictures of each of them using my imagination. Our relationships were not limited by what we looked like. I didn't see their broken bodies, or their sunken eyes as they strug-

gled through chemotherapy. I listened to what they had to say and I saw in my mind's eye who they were in their hearts.

To help me pass the time, my mother bought me a needlepoint set. I spent many happy hours learning to embroider, and I stitched lots of pictures with flowers and words, which I would give away to family and friends. I learned to think of creativity as a way to reach out to the people I loved. Learning to communicate with art brought me out of my shell. Most important, I witnessed the power of love at a very young age through my twin sister's action—and I experienced the fragility of life, as some of my phone friends died.

 never told those children how special they were to me because I never expected them to die. Through losing them, however, I came to understand how precious life is. Each heartbeat is a gift. Each life has meaning. Love is all-important and very powerful, and I have clung to that belief ever since.

My grandmother shares this philosophy. She, too, survived great loss when her twin sister, Grace, died at the age of twelve. At a young age, she was taught the heartwarming lesson that we are each given only this moment. Granny lived with our family when I was young. During the year I was homebound, Granny taught me about the power of creating something from nothing with your hands, by showing me how to knit. I watched her as she'd make granny slippers—these little knitted "shoes" to wear around the house. Her speed was incredible; it seemed that with a few clicks of her knitting needles, a pair of slippers would magically appear. Granny would turn out three or four pairs a day, and I'd sit enchanted by her skill, eagerly listening to her stories of whom she had given them to and why. Over the years, Granny's given her slippers to every single person she knows, and she knows a lot of people. The girls at the post office, her friends, the people at the bank, members of the card club, her children, her grandchildren, and even her great-grandchildren. We've all been given a special pair of granny slippers, and it's nearly as much fun to see the joy on her face as she makes and gives them away as it is to receive them. It's Granny's way of saying that she values and cares about you. At

Each heartbeat
is a gift.
Each life
has meaning.

ninety-eight, she continues to make them and they continue to give her life added purpose.

The desire to be creative didn't flourish only on my grandmother's side of the family. In 1901, in Baltimore, Maryland, my great-grandfather Issac Fuld and his brother William invented the Ouija board, now known worldwide for its supposed ability to conjure up messages from the spirit realm. That said, the stories of the board's origins that have been passed down through our family offer a somewhat different understanding of this creation.

The Fuld brothers were inventors who operated a toy and novelty company and were known for designing parlor games. The Ouija board was simply one of those parlor games, also known as a talking board. Although I am not an expert on talking boards, my understanding is that many others have been invented throughout history, some even dating back to the ancient Greeks. The name Ouija is a compound of the words for yes in French and German.

To play with the board as depicted on the original packaging, two people (a man and woman under the watchful eye of a chaperone) face each other, their knees touching, while holding the board across their knees. The fingers of both hands lightly touch a heart-shaped piece called a planchette. As they ask the board questions—perhaps scandalous ones such as "Do you like me?" "When will we marry?" or "How many children will we be blessed with?"—the planchette moves around the board spelling out the answers to the questions letter by letter.

For almost a hundred years people have been wondering how the planchette moves. Is it powered by the desire of the couple to speak secretively to each other and answer the romantic questions? Or is it fueled by a spirit that speaks through the board? We have to answer these questions for ourselves, but I feel that my great-grandfather believed more in the power of love than in the power of spirits. Poignantly, to me, the game gained enormous popularity during World War I, when mothers began to consult the board, asking for news of their sons who were fighting overseas. Today, the Fuld brothers' parlor game is still a creative, fun, and yes, artful way for people to share what is in their hearts.

The healing power of creativity really became evident to me during my second year of art college. A friend and fellow student suffered what doctors called a psychotic break.

One night I heard yelling outside our dorm building and there she was, out of her mind. The police arrested her because they assumed she was on drugs, but eventually they brought her to a psychiatric hospital, and she was committed to a facility in Rhode Island.

A few of us, all school friends, paid her a visit one day, but she had been medicated into what was virtually a catatonic state. We tried talking to her, but there was no getting through. It was as though we weren't there. On our next visit, somebody had the idea to bring along a few art supplies—just a sketchbook and some pencils. We left them with her that day. On our next trip, we learned that she had begun using what we had brought. At first she made some isolated pencil marks on paper. Later, she began to draw shapes and figures. Drawing didn't cure her, but it gave her a language to speak when actual language had slipped beyond her reach.

At the time, I was studying Carl Jung in school, especially his belief that images were symbols and art was its own language, like any other. It fascinated me, and I began to see that universally, all people use art to express the things they cannot say.

When it was time for graduate school, I continued studying art, but was also drawn to study psychology, combining the two to get my degree in creative art therapies. I did my thesis with deaf children, because they were unable to use words, yet still found ways to express themselves. I also worked with elderly people who had Alzheimer's disease. They'd lost their memories and forgotten how to use spoken language. My job was to help them use their remaining abilities to communicate, and I learned that they, too, could discover ways to bring forth what had been trapped inside.

Movement often held the key. We held hands and gently swayed to the soothing sounds of yesterday's melodies. On very good days, a spark of recognition would grace a tired face as they sang words to an old song. They used photo albums of days and people gone by to anchor floating and drifting thoughts. I had no doubt that these beautiful people had the desire to communicate; all they lacked was a language.

I also worked with men at a forensic hospital who had been arrested for crimes, but were found not guilty by reason of insanity. The technical classification was "criminally insane." I always joke that this experience prepared me for marriage and business, but

there was really nothing funny about it. These men had killed their wives or girlfriends or children, usually in some truly ghastly way. They were often a danger to themselves and anyone around them, including me and the rest of the staff. It was a tough experience, but fascinating, too, as these men were also able to find ways to communicate, even when their thoughts were scrambled by schizophrenia, even if all they could do was smile, yell, or scribble on a piece of paper.

From working as an art therapist, I quickly came to understand that it doesn't matter if we have lost our hearing, our memory, or our sanity—we will still be driven to communicate. And if that basic need is not satisfied, we become lonely, confused, and unhappy. When we become isolated and withdrawn, unable to connect with the people around us (and conversely, unable to receive or understand what people want to share with us), our unhappiness increases.

Everyone wants to connect, to belong, to love and be loved. When we are unable to relate with others in some meaningful way, our well-being becomes compromised. I have seen this in my own life time and again, and in the lives of my friends, my family, and my patients.

Ultimately, to find happiness, each of us must find our own unique way to express ourselves. As our personal language develops, so, too, does our creative nature. Both the intangible moments and the physical things we make become a vocabulary, just like any other language. In fact, they probably predate language. To be human is to create. We spend our lives trying to duplicate the act of creation that brought us (and everything else) into existence.

Once you recognize the truth in that, all the scrapbooking and cake-baking and flower arranging and gardening and dancing and laughter and hugging and crocheting and ceramics-making begin to take on new meaning. They are all ways in which we express things that words alone will never be able to say.

I see the goodness of Living Artfully up close, every day—in my life as an artist, art therapist, author, and businesswoman, and as a wife, mother, daughter, and sister. In traveling frequently and speaking to groups all over the country, I've seen so many of the end-

less ways we can live artfully, and have witnessed the passion with which people devote themselves to their own personal versions of artful living.

 can't promise that after reading this book you'll magically wake up one day with the free time and energy to turn every little routine task into a major expressive experience. But you will gradually begin to think about things a little differently. Somewhere in the back of your mind you'll remember how happy you feel when you make something—*anything*. You'll also realize that the things and moments you create really do improve your own life, and the lives of the people you love. Which inspires you to do a little more.

Maybe in the past you'd look at the calendar, notice that your husband's birthday is a week away, and make a mental note to order him a cake from the fancy French bakery near the train station. Now, when you notice the date, perhaps you spend a minute or two imagining what kind of fun surprise you could whip up for him on your own. That little moment of daydreaming is all it takes. I know somebody who, for her husband's fiftieth birthday, wrote her fifty favorite things about him on tiny pieces of paper. She then wrapped each one in aluminum foil and baked them into a big layer cake. (You just stir them into the batter before baking.) At his party, she asked guests who found the notes to read them aloud. It didn't take her much time or labor. But it made his night.

The single act of intending to start living artfully begins to work its way into your thinking. You automatically try to come up with reasons to make the extra effort. If you allow it to blossom, it reaches into nearly every aspect of your life, naturally, almost effort-lessly. It can inspire some big, ambitious projects, but also gestures that take just a minute or two.

There is great power in Living Artfully, and the smallest of efforts can yield positive results. Greeting the people in your life with a big smile sets a caring tone. Placing freshly baked cookies in the mailbox to be discovered by the postal carrier will give new meaning to "special delivery." Walking an elderly neighbor's newspaper from the curb to her front

Love is the

and to live

with the heart

expression.

is living

door on a rainy day is a gesture of kindness. Tucking in a few freshly picked flowers from the yard will make her day blossom. A hand-beaded bracelet shared with a sister will remind her that she is a "family jewel" and tell her how much you care. Take a moment for yourself, too. Slow down, hear the birds sing, smell the rain, see the flowers open to the sun. Taste life. Each of these gestures is a small acknowledgment that will resonate and multiply. Simple artful acts break through the chaos of your days, infusing them with a gentle order. Time slows and the people you touch will feel inclined to pass along this newfound sense of happiness.

At first, it might seem paradoxical to suggest that devoting yourself to Living Artfully—in essence, putting another thing onto your already full plate—will actually improve your quality of life. But it will. Because it's not about adding *on*, but about adding meaning *to*—to anything and everything you do. It's changing your perspective on your life more than it's adding something to your schedule. And by doing so, you will feel a true sense of accomplishment, of pride in having created a moment, a connection, or something beautiful with your own hands. You'll also have carved out a little time and space for yourself, a place where you can play and dream and laugh. When you're up to your elbows in dough or paint or yarn, you can't help but be a kid again. Best of all, you will have done something tangible to reconnect with the most important thing in life—the people in your life.

Lately, in my travels I've begun asking people why they involve themselves in creative endeavors. Their replies seem simple at first—they say that it's because they love to produce things that beautify the lives of family and friends. But when I dig a little deeper, they say things like:

"I love getting lost in the work. I feel relaxed and rested."

"I feel like I've accomplished something. When I knit a scarf, I see progress in every stitch and I know it's because of me."

essential ingredient,
fully engaged
is our ultimate
Living Artfully
heartfully.

"I feel really good about giving someone a piece I made. When something is made by hand it just has a different feeling about it. When I make something for a friend, it's because I want her to know that I really care about her."

"I could buy corn muffins from the store, but I wouldn't see the look on my daughter's face when they come out of the oven. It's a look that says, 'Did you make those for me?' We start the day with butter, jam, and warm muffins. I can't think of anything better than that."

Ultimately, Living Artfully nourishes the spirit. It gives you the time and tranquillity to handle everything else that comes along a little better than before. It invites you to open up your mind and heart so that you may see that we are creating ourselves in every moment in every day. Love, I believe, is the essential ingredient, and to live fully engaged with the heart, our ultimate expression. Living Artfully is to live heartfully. As the writer Antoine de Saint-Exupéry said so eloquently, "It is only with the heart that one can see rightly."

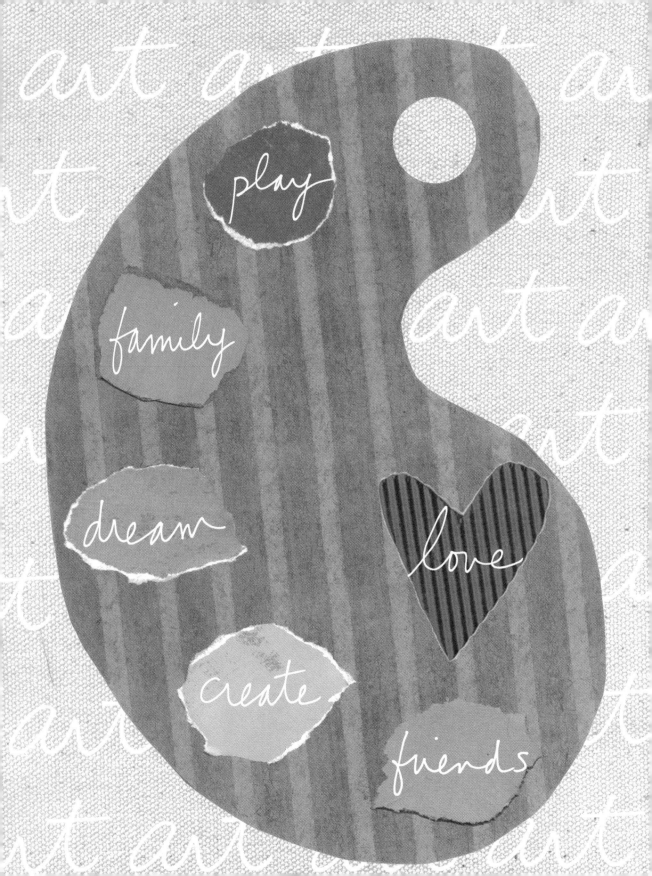

imagine

the possibilities

Rediscovering Your
Creative Power

As I begin this chapter, a new day is dawning. The sun, just below the horizon, paints the sky a soft orange, yellow, and pink light: a beautiful day, a new creation.

This day will be unlike any day that ever was or will be. Every moment is an invitation to live: to live it up, to live like it matters, to live life to its fullest, to live the life you dream about, to embrace life. Not just to get a life, but to create *your* life.

Each new day is a gift that we get to unwrap. And we each do it in our own way. Maybe you tear into the day as you would rip open ribbons and wrapping paper, or maybe you proceed slowly and deliberately following a plan, carefully untangling and refolding bows and paper.

Within this daily cycle of life lives the awesome power of creativity. This realization inspires and delights me every morning as the dawn breaks from the darkness. Every day grows and expands, becoming what it must be. Each morning is a reminder of your creative potential. Think of the morning as a lesson that is unfolding to show you the creativity in the fabric of all living things. What do you see today that you didn't notice or think of yesterday? Is there something about the light, your growing child, your spouse, your dog, your own feelings?

To be human is to be creative. You don't have to go outside yourself to find creativity—you already have it. It lives in your heart and mind every moment of every day. You have the power to summon your creativity anytime you like.

But why then are so many of us plagued with fear, self-doubt, and uncertainty about our creativity? Why do we say, "No one will think what I made is good," "People will make fun of me," "There is not a creative bone in my body," or my favorite, "I can't draw a

Think of the morning as a lesson that is unfolding to show you the creativity in the fabric of all living things.

straight line." When did rationalizations and excuses like "I don't have time," "I'll just make a mess," or "Everyone else in my family is creative, but I'm not" first stop you from embracing your creative power? Aren't you ready to put those aside and start up again?

When someone says, "I can't draw a straight line," I say, "Thank goodness!" Unless you use a ruler, no one can draw a straight line. It's impossible, first off, and second, who would want to? Lines that are curly, looped, scribbled, doodled, dashed, and freehand are beautiful. Lines drawn by hand reflect the heart. When people say, "I can't draw a straight line," I think they're confusing perfection and precision with creativity and uniqueness. They are defining creativity in a narrow way. Remember, creativity is found not only in artistic pursuits, but in viewing your life as a work of art.

 his chapter will show you what's keeping you from acting on your creative impulses. And it will help you develop your own art of creative thinking. It will invite and entice your creative spirit to come out and play, and ease you into an artful living mind-set. It will reveal how you can use imagination, playfulness, and simply being yourself as essential tools for living an artful, happy life. You will rediscover your individuality as well as old and new ways to communicate what you feel.

The pages ahead are filled with examples of people who have explored and expressed their true selves. Their stories will spark your imagination and help you move beyond any roadblocks that have been keeping you from living creatively.

 e're going to continue to think about art, creativity, and what you love to do in new ways. We'll start by redefining art, because the way you define words and ideas affects every aspect of your life. Ultimately, it affects how you define the meaning of your life. Here's an example of what I mean: one early spring when I was a little girl, I looked out at a sea of beautiful yellow flowers that had sprung up practically overnight in our front yard. They blanketed the lawn, their petals

reaching toward the sky like fireworks. I called to my father and said, "Look at these pretty flowers!" He stared at the yard with surprise and said, "Oh, those aren't flowers, Sandra. They're dandelions. They're weeds." Later that day, Dad came back from the hardware store with weed rakes for my sisters and me. As he handed them to us, he explained that our job that day was to rid the yard of those "weeds."

How Dad was unable to define those flowers as beautiful was a mystery to me at the time. But to him, beauty was a yard of pure green grass—like the other neighbors' yards. There was no place for weeds in his definition of beauty. It seemed like a rather narrow definition to me, and I certainly didn't like digging up those pretty yellow flowers, either. But years later, when I had bought my own home and become the proud caretaker of a well-tended yard, I confess that I, too, adopted my father's view of dandelions. That is, until one morning when my little daughter bounded through the kitchen door with a handful of sunny yellow dandelions and presented them to me with a big smile saying, "For you, Mommy."

In an instant, my childhood memories came flooding back, and I decided that those little yellow flowers would forever grow in our yard. We made a family ritual of blowing the blossoms as hard as we could after they went to seed in the late summer, whispering our wishes into the wind. I have never questioned the beauty and value of dandelions again. My daughter had reacquainted me with a familiar and treasured definition of beauty, and permanently redefined the word itself for me. Ultimately, this broad view of beauty affects how I see the world.

or too long we have too narrowly defined the word creativity so that only a few people can see themselves as creative. Often, the common definition of creativity goes something like this:

Creativity is the ability to use the imagination to develop new, original ideas or things, especially in an artistic manner.

To be human
You don't have
yourself to find
already have
your heart
every moment

is to be creative.
to go outside
creativity—you
it. It lives in
and mind
of every day.

But equating creativity with artistic talent and skills in this way makes us doubt that we can live up to its calling.

When we take a deeper look at the word *create,* however, we see that its origin is in the Latin word *creare*—to grow. To create, then, is to grow. We know what it is to grow something: to grow something out of nothing, to grow roses in the garden, to grow into your own shoes, to grow up, to grow a friendship, to grow through love, to grow into yourself, to grow more beautiful, to grow happier, and sometimes sadder, to grow life in your belly, to grow even after something or someone has left you, to grow from hardship or adversity, to grow beyond your years or fears, to grow older and wiser. To grow, always, means to be alive.

To grow anything we must nurture it, give it love, shower it with attention, tend to it with patience, care for it with kindness, and have faith in it. Creativity, too, needs attention to grow. Trust the power of this innate gift. Focus on it so you can discover how to nurture and grow it within yourself.

ow that you have this expanded definition of creativity as growing, take a look at your life. You will see that you are already creative. You're creative in everyday ways—in the ways you solve problems, juggle life, and make things work out. You're creative in the ways you live your life. Perhaps you, like many other people, have been looking for creative expression in too few places. Physical objects like sculptures, knitted scarves, and paintings are certainly creative, but so is the art of living. When your kids get bored in the car, do you quickly come up with a car game—either one you played when you were little, or one you just make up on the spot? How about when you organize a party for your children, friends, or loved ones—when you're picking out hats and cake decorations and party favors, does it ever occur to you that you're being creative? What about the way you arrange a gift basket for a friend, or the love you put into a photo album or homemade card for someone special? How often have you been praised for your present-wrapping abilities, your uncanny talent for throwing anything into a pot

and coming up with the tastiest of soups, or the way in which your children's clothes always look so cute? Even how you give your daughter a last-minute trim on her bangs as she's getting ready in the morning (so that she doesn't have to wait for her hair appointment for relief). Maybe you take a moment to connect individually with the kids in the carpool—so that they all feel special and nurtured while they're kicking off another big day.

You naturally infuse your run-of-the-mill responsibilities with fun, play, and creativity. In starting to recognize the special things you do, your inspiration will grow.

I know a woman who was tired of feeling rushed and frazzled in the mornings. She'd hurriedly walk her four sweet dogs, and then rush back to see if her husband had fed their nine-year-old son on time. Then she'd race off to drive him to school, but get caught waiting in traffic lines. She got creative. She decided to combine her two activities by walking her son to school *with* the four dogs in tow. All seven of them—she and her husband, one child, and four dogs—became a walking "party." Each morning they began a lively, new adventure. Cars slowed to view their parade, and they often saw tired-looking commuters glance over in surprise, then break out in wide grins and wave enthusiastically. Once in a while, someone would honk in appreciation.

Kids at the elementary school really loved seeing the family arrive at the drop-off area. After just a few weeks, as many as forty children would be waiting at the front gate for the arrival of their new furry friends—always telling the family about their own dog companions waiting for them back at home. It was like a traveling petting zoo. The boy stopped hating mornings (so did his mother) and started looking forward to school. Even the dogs appeared to walk with a newfound pride and purpose.

Imagine the possibilities when creative thinking becomes a part of everything you do. Remember, the only rule is that there are no rules.

Pablo Picasso said something so profound: "Every child is an artist. The problem is how to remain an artist once he grows up."

We are born with creativity, imagination, playfulness, and curiosity. Children act on these valuable attributes freely, discovering happiness, belonging, communication, and community through them. Can you remember when you were a child and anything was

possible? Search your memory for a minute. Allow your thoughts to go back to your creative beginnings. Ask yourself:

What did I love to do when I was a child?
How did I fill my days?
What mattered?
Who and what made me happy?
What are my most cherished memories?
What things and activities did I truly treasure?
What things did I really not like?

As you read the following examples, allow them to spark your own recollections of childhood. They may lead you to say, "Oh, yeah, I remember! That's like when I . . ." Hold on to the feeling this memory gives you. Think a little deeper: What was it that pleased you, made you happy when you were doing these things? Was it the making of something or the being with someone that you liked? As you read the following experiences, make a mental note of the ones that you feel a connection with.

Remember the forts or sanctuaries you built in the backyard, under the Ping-Pong table, in the big cardboard box in which the dishwasher was delivered, in the back of a closet, deep in the bamboo hedge that ran behind the alley, in the first big snowfall, or up in the oak tree? You created spaces of your very own. You met friends there, started clubs and teams, and sometimes you made believe you were stranded on a desert island and had to forage for food.

You decorated your sanctuary with curtains for charm, rugs for warmth, tree stumps for furniture, and tin cans as warning systems for intruders. You salvaged materials for building your havens, from cotton sheets and wooden scraps to newspapers, branches, paint cans, towels, old window frames, bike wheels, chicken wire, cardboard boxes, and aluminum foil. You could magically transform anything into a useful tool or material for your treasured abode.

"To live a creative life, we must lose our fear of being wrong."

Joseph Chilton Pearce

Remember lazy afternoons spent on soft green lawns, searching for buttercups for necklaces and four-leaf clovers for luck? You plucked the petals off daisies while saying, "He loves me, he loves me not." Stretched across the grass, listening to the buzzing of bees, you felt time stand still as white puffy clouds merged into a trillion images and shapes, including rabbits, dogs, cars, angels, and hearts.

You decorated bikes with red, white, and blue craft paper for the Fourth of July, and dressed up your dog for the local pet parade. You explored the woods and streams, searching for tadpoles, rocks that glittered, and butterflies that danced. You baked cakes in your Easy-Bake Oven and made stone soup and mud pies, decorating the tops with leaves, shells, and pebbles. You crafted paper kites and figured out how to make them soar, and you swung so high on swing sets that you thought you could fly. You played hide-and-seek and tag with old friends and found new ones along the way.

You played dress-up, trying on jewelry, gloves, hats, and dresses with sparkles as you tried on the role of princess, diva, mother, and superhero. You wrote, directed, and performed plays. You carted your latest "great thing" to school to share with others for show-and-tell, and you hosted tea parties for friends (some of whom just happened to be imaginary). You danced to "Ring Around the Rosie" and learned to line dance, tap dance, and ballet dance. You jumped up and down and jumped rope. You played leapfrog, pin the tail on the donkey, and monkey in the middle. You recited nursery rhymes, sang, played the piano, the kazoo, and the rubber band, too.

You drew pictures with chalk on the sidewalk, played hopscotch, and bounced a ball around the block without stopping. You skateboarded in the alley and made ramps out of trash cans with discarded wooden doors. You played with jacks on the front porch and hit the tennis ball against the wall off the back porch. You lit up dark nights with flashlights, and invented a code to signal your neighbor across the street. You slept under the stars and counted how many were really up there. You saw the man in the moon and the dippers, both big and small. You caught fireflies and made lanterns out of glass jars with holes in the lid, carefully filling them with the glowing insects to create a wash of yellow light.

Your senses were totally engaged, all day long, connecting with the beauty all around you. Effortlessly you created. You lived artfully each day. That creative spirit still lives within you. As you recalled your memories, I'm sure you recognized the many ways you lived creatively. Take time to remember how it felt to be connected to that part of yourself. Which childhood activities did you really enjoy, which did you want to do, but didn't? Write your thoughts down if that feels right, share your memories with someone you care about, or simply reflect on the details that you remember and reclaim them.

All the playing, imagining, and curiosity that served you well in childhood can again be renewed to enhance your quality of life, well-being, and ultimately, your happiness as an adult. "We are intended to remain in many ways childlike," the anthropologist Ashley Montagu once wrote.

We were never intended to grow up into the kind of adults most of us have become. We are designed . . . to grow and develop in ways that emphasize rather than minimize childlike traits.

What was it that made you happy, that enlivened you, that made you want to repeat those memories? Was it the sparkle of colors and light? The smells of the garden or the baking? The laughter and conversation in the games? The feeling of appreciation and camaraderie? Whatever senses lit up for you then may hold the key to the kind of thing or moment you want to make, experience, or give today. As an adult you can again connect to this untapped source of energy that is your birthright.

s a child you made mistakes, too (we all do). One day, my sisters and I filled a basket with corn on the cob we picked from a neighboring field. We carried the basket around our neighborhood, stopping at each house to sell corn to

women who were preparing dinner. We successfully sold all of our supply, and were thrilled to run home to tell Mom about our adventure and how we planned on spending our newly earned dollars. The phone was ringing as we barreled through the front door, and I heard my mom say, "Corn? Uh-huh, uh-huh. I see . . . Thank you for calling." I was sure she was going to say, "Nice work, girls! Great job. You're the best." Imagine my surprise when she put her hands on her hips, and in a serious tone said, "What in the world have you girls done now?"

We all answered at the same time, detailing our day's adventure and grand business efforts. "Well," Mom finally said as the phone started to ring again and again. "The corn you picked was *cow* corn and not meant for people!" My sisters and I had no idea such a thing even existed! "Isn't all corn corn?" we screamed. "No," Mom said, as she held back a laugh. "Cow corn is feed. It's hard and tough, and not at all edible for people." We spent the next few hours returning the profits back to our "customers" in the neighborhood.

I learned several invaluable lessons from this experience, which have served me well throughout the years. The first is that when you're selling something, make sure it's "people corn," not "cow corn." That is, make your message match your merchandise. And make it to connect with your customer. Next, the customer is always right. And finally, when you make a mistake, strive to learn from it and fix it. Find the gift in that "mistake."

We adults have somehow become afraid to make mistakes for fear of consequences that we presume might be dire. The truth is that we learn from our mistakes, and they give us the chance to do things over again in a better or different way. The terrible things we imagine will happen if we make a mistake often don't happen, and some very good things have resulted and been discovered from things that appeared to go very wrong.

Post-it notes are a great example of a "mistake gone right." A man named Spencer Silver was working in a 3M laboratory to come up with a new, strong adhesive. Instead, the stuff he created turned out to be weak, and it could be removed easily from surfaces. Four years later, another 3M scientist named Arthur Fry was in church, singing in choir, and was having trouble keeping markers in his hymnal. He thought of Silver's weak adhesive, which he recalled didn't damage documents when removed. Within a few more years,

Post-it notes were for sale nationwide and became one of the most successful office products available.

Popsicles, too, were a "mistake" invention. In 1905, an eleven-year-old boy named Frank Epperson accidentally left his drink out in the cold winter air overnight. The next morning, he found his drink frozen stiff, with the stirrer still inside. Using it as a stick, the boy found his "mistake" to be a delicious, easy-to-eat treat, and so did his friends. Years later, he brought out the newly named Popsicle, which became a worldwide sensation.

ur creativity naturally flourishes in childhood, but at some point, we are all confronted with the "grown-up" rules: we are told that playing is often inappropriate, that challenging the status quo is impertinent, and that asking questions can be disruptive. Conversely, following directions is worthwhile because rules are rules and facts are facts.

School starts and our days begin to be structured around the clock. We study details and dates, and our creativity is often put on hold until art class. Play is only for recess. These can be difficult days; sometimes we feel terrified and stupefied as we are being socialized and civilized. But this is not all bad. The beginning of school marks the end of one life and the start of a new one. We leave the security of our homes for a few hours a day for an exciting world with new people and places. Our desire to learn is at an all-time high. In early childhood, we primarily use the right hemisphere of our brain as we engage with life. Creativity, nonverbal communication, and intuition are the strengths of the right side of the brain. As we develop, our cognitive abilities grow, too, and the structure, direction, and instruction of school help the left hemisphere of our brain take on a bigger role—enabling us to think logically and analytically.

Ultimately, school is where many people learn about who they are, but schooling can overemphasize left-brain learning so much that the right brain feels shut out or shut down. Some ways of learning shake our belief in our natural abilities and skills—and in ourselves.

Today, we know from scientific studies that each part of our brain specializes in its own style of thinking and has different capabilities. Both parts are equally important. Ideally, you want to live your life using your "whole brain": you set goals with your left brain, but imagine and create your goals with your right brain. The way in which our left and right brains work together affects how we define and perceive our creative selves.

Pablo Casals, the great Spanish cellist, railed against left-brain schooling:

> And what do we teach our children in school? We teach them that two and two make four, and that Paris is the capital of France. When will we also teach them what they are? We should say to each of them: Do you know what you are? You are a marvel. You are unique. In all the world there is no other child like you. In the millions of years that have passed there has never been another child like you. . . . You have the capacity for anything. Yes, you are a marvel.

When I read this quote, I wished that we would all be told what marvels we are so that our belief in ourselves and in our potential would never fade.

If you were told by your teacher to color "inside the lines" with a red crayon when drawing an apple, for instance, but instead you insisted that apples were green or yellow, you probably didn't get a star on your paper, or even a happy face. Perhaps your class was graded for following directions in drawing and coloring, but because you marched to your own drummer, you were treated like a failure or scolded for being messy. Because so much of what we did in those early school years was with art materials, some children came to see these "artful" activities as traps. School was a place where they began to feel judged, embarrassed, censored, criticized, and measured against in a competitive setting. Many wrongly came to the conclusion that they were simply not creative.

The reality is that as a child you were asked *not* to use your creative skills but instead

were asked to follow directions. If you didn't follow the instructions, maybe your art was not displayed on the wall with the others by children who did conform. When a learning environment stifles our innate creativity, we slowly begin to lose our enthusiasm and passion for our artful gifts.

Parents, grandparents, teachers, siblings, friends, and neighbors also impose on us their expectations of what is appropriate behavior. People impart the "essential" rules and regulations (as they see them) for living a worthwhile life. When they do this to guide us as children, they're helping us "grow up." But an overemphasis on rules can make us fear we won't measure up, that we won't do things like "everyone" else, that our differences won't be accepted, that we will fail so badly that we will be too afraid to try again. We can get stuck in self-doubt: doubt in ourselves, doubt in the way we do things, doubt in what we knew to be true, doubt that everything will work out. That's why I always say the only rule is that there are no rules. We need to free ourselves from the restrictions we were taught to put on ourselves.

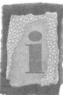t's no surprise that a UCLA study documented what we already assumed: on average, at age five we engage in creative tasks 98 times a day, laugh 113 times, and ask 65 questions. By age forty-four, the numbers fade to 2 creative tasks a day, 11 laughs, and 6 questions. I want you to decide to reverse the slide in these numbers in your daily life. And a good place to start is by asking questions. And asking questions won't take a lot of time—you can ask yourself questions wherever you are: while in the shower, over breakfast, driving your car, or commuting home on the subway, bus, or train. Ask yourself: Is this the way I want to do this or is there a different way? Is the fastest way always the best way? What's my purpose in doing what I want to do? What's the message I want to send? Am I wanting to make someone smile or give a helping hand? What rule am I observing by doing what I'm going to do and what rule am I breaking by doing it differently? Questions will lead you to use your curiosity and rethink what you're doing and find new ideas.

hen we say, "There is not a creative bone in my body," "Everyone else in my family is creative, but I'm not," "No one will think what I made is good," "People will make fun of me," or "I'll just make a mess," we are replaying an old record from our childhood and we don't need to listen to it anymore. As an adult, you can choose to make a mess, decide to dig into a new technique or material, and review your creations based on your likes and dislikes, not by what others might think. You don't need to hide your creative self to protect it anymore.

My twin sister was always a very good writer; words seemed to come easily for her. She wrote poems and letters and speeches for all of our family occasions. She was the writer of the family. Words didn't come easy for me, however, and having to memorize the rules of language and grammar crippled my desire to express myself in full sentences. I was called the artist, even though my sister loved to paint and draw and make crafts, and I longed to write.

Because I was told she was the writer, I stopped writing. Because she was told I was the artist, she stopped painting. Although our family meant no harm in its identification of our perceived skills, the voices of our inner critics grew, as did our self-doubts. It took us each years to shed those narrow definitions and judgments so that we could fully use our innate gifts. Ironically, so much of my own art carries messages in it—words and whole sentences: Today, I create baby apparel that incorporates words and verses and that I hope will inspire parents and caregivers as they raise their children with love, compassion, and care; I make greeting cards that use images and language to express a wide range of sentiments for the everyday, as well as celebrations and seasonal holidays; and the pottery I make is inscribed with simple truths, inspirations, and messages meant to touch one heart at a time.

s an adult, you want to dig out and discard any old feelings of judgment, criticism, or doubt. Replace them with kindness, respect, care, compassion, understanding, and love. People don't grow when they are fearful. They shrink, hide, and diminish. You *can* rediscover and embrace the creative part of your nature. You will shine and grow as you reveal it and yourself to the world.

> Whatever you can do or dream you can, begin it. Boldness has genius, power, and magic in it. Begin it now.
>
> —Goethe

You were born with the drive to grow, to create. You might have forgotten the impulse, but it is still there inside of you. As the anthropologist Ashley Montagu suggested in his book *Growing Young,* adults learn from children about the essential nature of fun and abandon in order to prevent "psychosclerosis," the hardening of the mind. He prescribed the following traits of the child to avoid this dreaded condition:

> The need for love • friendship • sensitivity • the need to think soundly • the need to know • the need to learn • the need to work • the need to organize • curiosity • a sense of wonder • playfulness • imagination • creativity • open-mindedness • flexibility • experimental mindedness • resiliency • a sense of humor • joyfulness • laughter and tears • honesty and trust • optimism • compassionate intelligence • dance • and song.

How do we translate the intrinsic and valuable qualities of creativity into adulthood? How can play, imagination, curiosity, and invention be a part of every day? This quote by Gilda Radner, the comedian who died too young, is a great reminder of the importance of being you:

> While we have the gift of life, it seems to me the only tragedy is to allow part of us to die, whether it is our spirit, our creativity, or our glorious uniqueness.

I believe that we each have the individual responsibility to bring forth ourselves into the world.

Creativity helps you gain confidence, self-understanding, and self-esteem. It increases your concentration, helps you learn to take risks, and creates balance and order. You can make mistakes more freely and solve problems with increased flexibility—skills that enhance all your relationships. Creativity supports innovation, invites you to savor a moment, engages your senses, and helps you see the beauty in all things. It leads you to imagine unlimited possibilities.

Give yourself permission to be you. Stop censoring your actions. Be you—the only you there is. No one else is qualified for the job. Have fun, have a sense of humor, and have a million laughs. Be an optimist, be the person you were as a child. Do something new, exciting, and different. Look at life from a different point of view. Get curious; ask a trillion questions, and experience the joy in looking for the answers. Make new friends and cherish the old (some are silver and the others gold). Invite creativity to become as much a part of the fabric of your daily life as are your everyday routines, like making the bed, cooking meals, cleaning the house, and caring for the people you love. Look at these everyday, seemingly mundane tasks and see where you can infuse them with spirit, individuality, and fun.

Think of yourself as creative. I heard a great story of an English art therapist, Edward Adamson, who asked a group of high-school-age children to look at a brick and write down as many things as they could imagine the brick being used for. Some children had no problem, easily writing a hundred ideas. Other children struggled, so he asked those children to close their eyes and imagine that they were eccentric artists known for their creative flair. Once they had an image of themselves as innovative, artsy people, he asked them to open their eyes and again look at the brick and write down all the things the brick could become. This time, the children overflowed with ideas. The difference was they now saw themselves as "artists." If you think of yourself as a creative person, you will

begin to act in creative ways. Use this new perspective of yourself and act "as if" your work, chores, commute, and duties are outlets for your creativity—and they will be!

Be innovative. Recycle and reuse materials in artful ways. When my sisters and I were little girls, our mother always covered our schoolbooks with the brown paper bags that groceries were packed in. She carefully cut and turned the bags inside out and then expertly folded the paper around our books. I loved these book covers because they were perfect to draw on. Each was a blank canvas, where markers, pen, and even paint glided on the surface with ease. The paper was thick and sturdy, and my books remained covered for most of the year in these personally decorated jackets. Mom also lined the shelves of our pantry with the paper from these bags and crafted costumes out of them by cutting holes in the bottom and sides (for head and arms), giving us paint to cover them. She laid them on the floor of the car as a mat when our feet were muddy; she cut them into pieces to make bedding for our hamster cage; and she tore them apart to make papier-mâché material when we needed to craft a volcano for school. In a pinch, she'd use the paper to tie up a package and wrap it up with string. It always reminded me of the lyric "Brown paper packages tied up with string, these are a few of my favorite things" in the movie *The Sound of Music*. To this day, I still wrap gifts in brown paper, loving the simplicity and beauty of the finished package.

When I was in college, in art school, I decided to study printmaking. This class required purchasing lots of paper to print on. It was a struggle for me to be able to afford the pieces of handmade, beautiful pulpy papers, as I was a "starving student" and they were expensive. One day at the grocery store, the clerk at the checkout asked, "Paper or plastic?" and it suddenly hit me that here was the paper I could print on! I remembered the books my mom had covered and realized this hardy paper would be perfect for my class. Sure enough, when I got back to my room and painted on the brown paper, I created a patina that I really loved and that was unique to my style. The paper gave my art a touch of age, a bit of a distressed look. Today, I paint all my illustrations on this brown craft paper.

For me, being innovative grew out of the necessity for supplies.

Innovation is simply the idea of using and seeing things in new ways. Each of us can imagine the possibilities in anything and everything.

Play! You don't have to look far to see examples of play at work in the world. It always makes me feel soulful and happy when I watch Ellen DeGeneres dance at the start of her daily talk show. Ellen is just being herself—her playful, creative self, dancing for the sheer fun of it. Then the audience stands and starts dancing with her. Each day fans cheer for the ritual to continue. Dancing at the start of the show has become her signature—a way for Ellen the "host" to connect with her audience. Her carefree individual style of play has given others the permission to do the same. Take a dance class, go bowling, play cards, ride a bike, take a hike, have fun. And play often.

Let your imagination take you places. My girlfriend's father had a very stressful job as a stockbroker. Because of the volatility of the markets, he didn't take many vacations. He liked to joke that he was "chained to his desk," but it was achingly true. He and his wife of thirty years had always wanted to learn about the world and travel, like their friends were doing who had newly retired and were now enjoying their freedom by taking trips to different parts of the world. But this man had lost a fair amount of his earnings in the stock market, and his retirement was now many years off in the distance. Rather than feel sorry for himself, though, he got creative. Living near a university, he quickly discovered that every Wednesday night, in the main auditorium, was travel-film night. And it was open to the public.

Week after week, year after year, the man and his wife journeyed to Istanbul and Turkey, Greece and Italy, Russia and Australia, as well as places he never knew existed and could barely even pronounce. He liked to brag that at least his wife didn't have to get "those horrible shots" and find a pet sitter and stress out about what to pack. Their travel was from the comfort of a padded movie theater seat. To put his own creative imprint on the night, and add a little local flavor to their "trips," he started taking his wife to dinner beforehand, finding restaurants that served food of the origin of their movie destination.

Creativity helps you gain confidence, self-understanding, and self-esteem.

For a reasonable amount of money (certainly far less than if they had actually ventured off to these countries), he and his beloved treated themselves to joyous evenings of entertainment, play, enrichment, and education. He felt like he was always in a perpetual state of discovery, and reading up on each destination before their "arrival" made him feel like an active participant.

The man and his wife had so much fun in their fantasy travels that their friends began joining them, and before long it was a bonding experience shared by a group of more than thirty people, even some who were "real" globetotters. By the time he died, this man felt as if he *was* a world traveler, despite hardly ever "going" anywhere. His curiosity about the world, other cultures, and international cuisine was all satisfied through this simple example of Living Artfully.

Make new friends. A young woman moved into her first home—a tiny one-bedroom bungalow in Los Angeles. She fell in love with the house immediately, not just because it reminded her of simpler times, and because it was known to be a family-friendly area, but also because of the gigantic fig tree growing out back. The woman had been raised in a house in Northern California with a large fig tree, and the deep purple fruit reminded her of home and of her mother, who had since died.

Soon after moving in, however, she was saddened by the amount of fruit going to waste on the ground. "What can I possibly do with all of these figs?" she wondered. She had already given bags of them to everyone she knew, and couldn't keep up. They were so fragile and spoiled easily. She remembered that her husband had a book with a recipe for fig preserves. "Why not?" she thought. "What have I got to lose?" Never having made jam or preserves before, she had a moment of fear, but pushed on. Several hours later, she and her husband were oohing and ahhing at their magnificent creation. The fig preserves were the best-tasting jam they had ever had, and they were so proud of themselves for discovering this recipe together. They walked across the street, knocked on doors, and shared them with their new neighbors, who all agreed this recipe was the "very best." Within a day she'd knocked on every door in her neighborhood and made many new friends with the fig jam.

Smile and laugh. "We shall never know all the good that a simple smile can do." Mother Teresa reminds us that a smile has great power to connect, to heal, and to uplift. My daughter and I were driving to the store when she was eleven or twelve years old, and I noticed she was waving to every car around us. I saw her smiling and the people in the cars around us smiling and waving as well. When I asked her what she was doing she replied, "The last time we went to the store, I waved at twenty-five people and twenty waved back. Today I waved at thirty people and thirty waved back and smiled." For my daughter on this day, her success was measured in smiles and greetings. Aren't smiles and greetings the measurement for joy and success for all of our lives?

Come to your senses! Use all of your senses as you engage in the world each day. Use them by tasting, smelling, touching, seeing, and hearing life. Our senses are our most valued resource for living creatively, yet far too often we ignore them. We eat dinner on the run, not tasting the flavors or textures. We don't see the wildflowers growing by the mailbox or on the side of the road as we are hurriedly scurrying off to our destination. (Remember, the joy of the journey is in the ride.) We don't smell or feel the rain as it falls to nourish the land; too often we blame it for dampening our spirits. The way I see it, we have to put up with a few raindrops if we want to see a big rainbow.

Listen for the birds before you even get out of bed. Take in the sky as the world begins to wake up. I know you've heard it before, but stop and smell the flowers. Savor the scent of a freshly brewed cup of coffee or tea. Taste its silky warmth. See the steam rise gracefully from the surface of its smooth cup. Hear the quiet of the morning as you nourish your body and your soul. Create the day and the life you imagine.

Live artfully.

night
night
night
night
night
night

everyday ART

Creating Moments That Matter

 know of a hospital gift store where the manager hands out smiles to customers. Perhaps you're thinking I mean she flashes her pearly whites at people all day long. I'm sure that's true, too, but she also keeps a ready, abundant supply of paper smiles on wooden Popsicle sticks behind the counter. She hands these little gems to doctors, nurses, patients, and visitors who are simply having "one of those days." Folks come to the store to purchase mints, magazines, greeting cards, or a little gift, and they leave with a big smile and a profound sense of connection. This thoughtful, artful gesture is a reminder that a smile is a little curve that can straighten things out.

A friend told me about her neighbor Bob, who had lived next door to a woman named Caroline for over thirty years. He and his wife looked out for Caroline after her husband died. Each day on his way to work, he picked her up and drove her to the bus stop before heading off to work himself. After many years, Bob retired, but rather than sleep in each day, he continued to get up and drive Caroline to the bus stop every morning. On days that were cold or rainy, he'd wait with her in the warm car until the bus arrived. It seems that Bob stopped carpooling when he retired and began "carepooling."

Everyday ways of Living Artfully bring family, friends, acquaintances, communities, even strangers, closer together. These acts, which are sometimes silly but always kind, enhance our joy and prosperity of heart, and have the power to strengthen the bonds that support and sustain us in times of need. Like the pebble thrown into a pond, ripples of a thoughtful deed widen out to touch many lives. Appreciation and tenderness are passed along by gratitude, and in this way the "everyday" gains momentum to benefit others we may never see or know.

Your days are just waiting to be enriched with creative thought, joyful purpose, and inspired meaning.

This chapter focuses on how to live your life as if it's a work of art—infusing heart, creativity, and clarity of intention into your everyday actions. It begins with the smallest gesture, something as uncomplicated as saying good morning to the man stacking oranges at the grocery store, placing a bowl of blooming paper-white narcissus bulbs on your kitchen table in February, or sending a postcard to an old friend.

Your version will be your own. Some people whistle and others sing arias. From planting colorful marigolds in a pot and placing it on a neighbor's front door step, to volunteering your time to restore a community flower garden, this chapter will help you find your unique voice through artful forms of self-expression.

Life is your canvas; no one can paint it but you. Each moment is an invitation to create yourself and the life you've imagined. Too often we wait for a "big" occasion or "just the right moment" to celebrate life. But it is the little things in life that make living so grand. The stories and simple (yet profound) suggestions in this chapter will help you live artfully as you go through even the smallest daily task, the most repetitive chore, and the most predictable routine. Your days are just waiting to be enriched with creative thought, joyful purpose, and inspired meaning.

I once heard someone say that if you don't stand for what you believe in, you'll fall for anything. When you act on your impulses to play, when you are open to the possibilities in each moment, you replace your fears with self-understanding, self-esteem, and personal strength. You show the world who you are and what you believe in. So, acknowledge and validate your intuition, your curiosity, your thoughts, and your dreams. They are yours and yours alone. Like DNA, snowflakes, and fingerprints, you are one of a kind, an original.

You can start from the moment you open your eyes. Do you bemoan the untimely arrival of morning and hit the snooze button four times before regretfully stepping out of bed, or do you arise with a smile and a sense of gratitude for the new day? A Native American medicine man bows to the four directions when he awakens, and thanks "Mother Earth" for the gift of one more rising sun. A girlfriend of mine gets on her knees every morning and kisses the ground, saying a silent prayer of thanks for the chance to start again. By just saying good morning, you are acknowledging the new day. These are simple,

yet powerful affirmations in the goodness of life and your place within it. Make up one of your own.

As you dress in the morning, use clothing or jewelry or makeup or perfume or every-day odds and ends to accessorize what's going on inside you. Throw together a look that says how you really feel. Perhaps you're feeling outdoorsy, and you want to express your-self with hiking boots, thick socks, and a bandana covering your hair. You choose a natu-ral rose oil for your perfume on this day, and you decide to eat outside under the stars to make dinner a little different. Or maybe you're in a more exotic and foreign mood, and an East Indian sari or long dress would feel just right, with big gold or silver bangles adorn-ing your left arm. If you're in a romantic mood, you can wear fabrics that have a gypsy flair, or tight bodices with a flowing skirt that accentuate your figure.

If, on the other hand, you want to dress in a really funky way, you might tie one of your husband's patterned ties around your waist as a colorful belt or sew two or three together to make a distinctive scarf. Be innovative, like when you were a child. Remember the necklaces and bracelets you made out of gum wrappers, garlands of flowers, or rainbow-colored Froot Loops? The thing to remember is that anything can become something, and the object is to honor your many moods while having fun!

ather things you love from where you are and use them to make whatever moves you. While on vacation in Maine last summer, I drifted in and out of antique stores, junk shops, and yard sales. I picked up little things that caught my eye: forgotten buttons, scraps of fabric, old sheet music, and charms that had long ago fallen off their bracelets. As I strolled on the beach, I felt lucky to find broken pieces of painted china, small pieces of driftwood, and worn sea glass in a variety of colors, shapes, and sizes. At sunset, I poured myself a glass of wine, toasted the day's end, and began tin-kering with the loot I'd collected.

I found a long piece of twine in the house we rented. I think its original use was to tie up the newspapers for recycling, but I had other designs on it. In my cosmetic case, I found a

When you act
to play, when
the possibilities
you replace your
self-understanding,
personal

on your impulses

you are open to

in each moment,

fears with

self-esteem, and

strength.

sewing kit from a hotel. As the natural light of day faded, I began stitching the bits and pieces of my day's journey onto the twine until my eyes got tired and the rumbling of my tummy called for dinner. Every evening, I added a few more treasures to the twine. At the end of the week's vacation, I tied a knot in the now highly decorated cord, and slipped it over my neck as I headed to the car for the drive home. Whenever I wear my creation, I am instantly transported to the feelings of rest and relaxation, and the memory of a time I cherished.

ach day, life unfolds, revealing triumphs, sorrows, and everything in between. At home, work, or school, we make friends, fall in love, raise children, and relate to other people as daughters, sons, mothers, fathers, lovers, friends, coworkers, wives, or husbands. With each new day, we choose how we'll create and nurture our relationships with the people we value and love.

How do you tell people they are special to you? At breakfast, try spelling out "I love you" with individual letters from alphabet cereal. Of course you will have to pick through the box to find eight letters, but the message will then have your personal touch. Write "You're my favorite" on the bathroom mirror in soap or lipstick where your spouse brushes his or her teeth. Surprise your son with his favorite cookies in his lunch box—the sugary ones that he regularly begs for in the grocery aisle, but rarely receives.

Winston Churchill said, "We make a living by what we get, we make a life by what we give." In our perpetual rush, we often whiz past or fail to see the things that really matter most. We put off finding the time to tend to the significant friendships and people who are right before our eyes or under our nose. Are we so busy running the rat race that we no longer see that we might already have won the race long ago? As the great comedian Lily Tomlin said, "The trouble with the rat race is that even if you win, you're still a rat." Living Artfully will help to slow the pace of your life and refocus your sights on those people and things that cannot be "won," but that could be lost through inattention. Life can be harsh and it can be shorter than we wish, so loving shouldn't be left to "later" or "tomorrow." It's not a part of any race.

The best gifts are the people in our lives and the moments we share.

The power of love can be seen in the ritual of an East African tribe that begins communicating what they feel in their hearts even before a child is conceived. When a mother wants a baby, she goes off alone and listens soulfully, until she can "hear" the song of the one she hopes will be born. Then she returns to the village, and she and her husband, the father-to-be, sing the song together as the child is conceived. As she carries the baby inside her, she teaches the song to the village women and midwives, who will all welcome the new soul into the world at birth by singing the baby's song. Throughout the person's life, at times of ceremony, joy, or sadness, the song is sung, and it is the final refrain after death, as the body is laid to rest. From the beginning to the end of the soul's incarnation, the tribe communicates the message that the child is treasured and loved.

What kind of song would represent your life? Would it be parts of several different songs? A hymn or ballad? A guitar solo? What music stirs you, touches you, moves you, and reminds you that life is a song and you can sing along?

Living Artfully is not about perfection, following directions, or anybody's preconceived notion of success. Living Artfully is spontaneous and casual. It can be wildflower seeds spread secretly for a spring surprise, or a sidewalk cleared of snow. It can be a smile, a touch, a kiss, a wave hello, or a gentle nod of approval. It can include sitting with a child and making a colorful countdown-to-my-birthday paper chain, or fashioning snowmen from laundry soap flakes and water.

You can find artful acts everywhere. Over an eleven-month period, Mierle Laderman Ukeles shook hands with eighty-five hundred New York City sanitation workers and thanked them for keeping the city clean. At the time, they were still called "garbage men," which bothered her because she felt that their work was extremely important—it allowed everyone else to live in a beautiful place. By shaking their hands, she was saying, "Thank you for keeping New York City alive," and letting them know that many people appreciated their efforts. Sanitation, she pointed out, is not the same as garbage. "Sanitation creates order out of chaos, and in that way, it's artlike."

I came across a great quotation in a book one morning, and on a whim, went into my daughter's room while she was out for the day with friends and wrote it on her chalk-

board. It was by Eleanor Roosevelt: "The future belongs to those who believe in the beauty of their dreams." I hoped it would give her a lift, inspire her, and make her a little happier. I hoped it would remind her that she's always in my thoughts. I hadn't realized how much she loved discovering these quotes in her room until the morning she asked, "Mom, where's my quote?" I had lapsed in writing them down, and she missed them and wanted more. Ever since, in the course of my daily routine, I'm always on the lookout for new quotes for her chalkboard.

"Self-trust is the first secret of success" (Ralph Waldo Emerson); "Try not to become a man [woman] of success but a man [woman] of value" (Albert Einstein); "The power of imagination makes us infinite" (John Muir); "To climb steep hills requires a slow pace at first" (Shakespeare); "People from a planet without flowers would think we must be mad with joy the whole time to have such things about us" (Iris Murdoch).

Gathering this timeless wisdom is no big deal, and it requires almost no effort on my part. But it has become another way to tell my daughter how much I love her and care about her. It puts me in her life in a nice, uplifting, amusing way, which makes me happy, too. Not bad for a couple of seconds' worth of work. I could just tell her I love her, and of course I do all the time. If I have some advice, I could simply just offer it. But somehow, making these moments tangible turns them into something lasting.

Words are important. Speaking our hearts, face-to-face, is necessary. But our spirits long for more. Don't you love getting cards and gifts, not because you're materialistic, but because you love the thought behind them? It truly is the thought that counts. These priceless artifacts of kindness stay with us in ways that spoken words alone do not.

Sometimes everyday artful living has the power to transform a town, a city, or a community. Thirty-four years ago, a woman named Maisie DeVore of Eskridge, Kansas, had to

drive to another town to take her kids for a swim during the hot summer months because her town didn't have a public pool. Knowing that many local children weren't as fortunate and didn't have access to a car, she dreamed of raising money for a public swimming pool to be built in her area.

This enormous project she envisioned required extensive funds, which she didn't have. Undeterred, Maisie began collecting tin cans and scrap metal and car batteries and other "junk" wherever she went, and exchanged it for money at the nearest scrap metal recycling center.

It took thirty years, but Maisie raised more than seventy-three thousand dollars on her own, which inspired the local government to match the funds. The DeVore Community Swimming Pool was completed in July 2001. At eighty-three years young, Maisie is able to watch as children from her area and neighboring counties—as well as arthritis sufferers, spinal cord patients, and seniors—gather at the pool, cool themselves on a hot day, and have a little fun. Maisie's generous and creative solution to "finding a way" reaffirms the simple truth stated by Albert Einstein that "imagination is more important than knowledge."

Love doesn't just make the world go round; love is what makes the ride worthwhile. If love were a place, it might well be the most beautiful place in the universe. Trust, understanding, affection, passion, acceptance, and kindness would abide there. Although love is of course not a physical place, it does reside deep inside our hearts and spirits. When you love someone, let him or her know—be romantic, playful, and curious about what the person loves and what makes him or her happy. Use your imagination to help create a relationship that will not only grow and flourish during the sunny days of summer, but will also withstand all the storms throughout your journey together.

Recently I was traveling on a flight from Baltimore to Atlanta. On the plane sitting near me, several soldiers were returning from overseas for a two-week break from the war in Iraq. The men were talkative and excited, immeasurably relieved to be going home.

One soldier eagerly told us that his wife and two children would be in Atlanta to meet him. Close to tears, he added that one of his children was a baby, a son, whom he would be meeting for the first time. Another fellow could barely sit still, waiting to reunite with his wife, who would be at the airport.

Exiting the plane in Atlanta, I was reminded that people are the most cherished gifts. I watched teary-eyed as one soldier quietly and gently unwrapped the gift his wife held in her arms, his newborn son.

At the same moment, a woman stood at the end of the gate, wrapped in the biggest yellow ribbon I have ever seen. The soldier, her husband, whom I had just been chatting with on the plane, was speechless. Overwhelmed by seeing his wife wearing that yellow ribbon, he walked through the gate, they embraced, cried, and everyone around them cried, too.

I was reminded that the best and most treasured gifts are not found in a store, enclosed in a box, or discovered under a Christmas tree. The best gifts are the people in our lives and the moments we share.

> If a man is called to be a street sweeper, he should sweep streets even as Michelangelo painted, or Beethoven composed music, or Shakespeare wrote poetry. He should sweep streets so well that all the hosts of heaven and earth will pause to say, "Here lived a great street sweeper who did his job well."
>
> —Martin Luther King, Jr.

For years this quote has been hanging in my studio. It's a constant reminder to me that our work is also our art. We work because we have to make a living. But we also work because it is, in part, how we make a life. Who we are is reflected in what we do and how we do it. Do what you love, work at something you believe in, do work that matters, work because you must, and because you make a difference in the work you do.

A woman named Dee is famous at a hospital where she works for writing poems that

say farewell, thus honoring coworkers who, for whatever reason, are leaving the job. For ten years, Dee has been the hospital's "poet laureate," and everyone knows that a good-bye party is not good until Dee clears her throat, places her glasses on her nose, unfolds her paper, and gives a poetry reading. Here is an abridged version of one of Dee's poems:

For Penny in Accounting

Penny joined us just nine years ago,
a happy, cheery, smiley person we all came to know.
Her banking experience showed true, in the part-time position.
A few years later, a full-time job came to fruition.

The checks were many, the order batches diverse and full.
During the busy season, a constant push and a pull.
There were invoices, spreadsheets, and the infamous agent tapes.
Penny was top-notch, while thinking quietly of Bermuda escapes.

With Penny's easygoing attitude, to work with her was great.
Never a problem arose that she couldn't resolve first-rate.
Her genuine kindness to others, a highlight of her personality.
Even at the most difficult times, she glowed with sensibility.

The time has come; Penny's leaving us and taking the chance.
Going to her job "by the Bay" is definitely an advance.
There will be new people to meet and new things to learn.
It's a good move, a wonderful opportunity and it's finally her turn.

Now, here it is, Friday, August first, two thousand and three.
We're here to say, Congratulations, Good Luck, and on that we agree.
Just remember, though; between here and there, it's only a short drive.
We'll keep the lines open, so our friendship continues to thrive!!!

Donna is a bookkeeper at an art museum. She also holds the secret recipe to her grandmother's nut rolls. From time to time, Donna surprises the staff by baking these famous confections for breakfast at work. Her coworkers are thankful for her skills as a "bean counter" on the job, but they go "nuts" about her ability to make warm buttery rolls. Everyone gathers to share in the treat before the day starts. Donna loves that her rolls bring a little sweetness to the day and big smiles to the faces of her coworkers.

iving Artfully can offer healing in challenging and troubled times. You know the days—they stop you in your tracks. These are the moments when you just can't make sense of anything. We will never know why painful, tragic things happen, but we can learn how to respond to them to help others and ourselves.

Recently a woman told me that when her best friend passed away, she was consoled by the stories people shared at the funeral. She loved hearing the way her friend had touched each and every person in her own unique, special way. Following the funeral, she sent a letter to all the people who had signed the guest registry and asked them to send her a story, a picture, or a thought about their departed friend and loved one. The response was overwhelming. Letters, notes, cards, and photos came pouring in. The woman took great delight in reading each and assembling them all in a book. Together, the stories painted a picture of a life filled with happiness, friendship, kindness, and worth. At first the woman thought she would assemble one book and give it to her friend's parents, but after she completed it, she knew that would not suffice. She had the book photocopied and sent a copy to every person who had contributed something to the book, saying, "I realized that our friend's story is our story, too."

My daughter, Hannah, came home from high school the other day worried and sad that her friend was feeling low. She went to the computer, made a CD of her friend's favorite songs, and printed out some of the corresponding song lyrics. She fashioned a book from some nice paper and then she made and attached a special envelope for the CD into the booklet, and pasted the lyrics alongside a few pictures of her friend and other

close friends. The next day after school Hannah came through the door with a huge smile. "I made her day!" she sang. Her friend, who had been feeling lonely, was deeply touched that Hannah had cared enough to make a special book for her. She also was reminded that she had lots of friends who cared.

In our local newspaper I read about a group of women who created a quilt for a recently widowed friend from the fabric of her late husband's clothing, making a beautiful blanket to cover their grieving friend in love.

Artful acts help soothe an aching heart or comfort a grieving friend. They give someone something to hold on to when she's lost someone dear.

Every once in a while I come across a writer whose words reflect a heartfelt understanding of what it means to living artfully. Learning that she had cancer, the humorist and writer Erma Bombeck wrote a poem entitled "If I Had My Life to Live Over." In this wise and timeless affirmation for living life with passion, Bombeck identifies what really makes a life well lived, and reminds us to seize the moment, take time for ourselves, give frequent hugs, appreciate what we have, listen attentively, and be present for friendship—and for little moments with big meaning and great love. Her words are a reminder to live like you are dying.

Take a look at your own moments, your day, your relationships, your attitudes, your beliefs, and the world you've created. Ask yourself, "Am I living the life I want?" If you can really look truthfully and answer yes, congratulations! Good for you; keep it up! But if you answer, "I don't think so," then start this moment. Create one moment that brings joy to your life. Play a song you love, sing out loud, slip into a warm bath, sip a cup of tea, dance, dance more, make a call to someone you care about, lay on the grass and look at the clouds, hug, kiss, read a book. Keep searching until you feel completely caught up in the moment, until you create the moment and live it fully.

Each day, make another moment feel special, followed by another and another. Our lives are made up of these meaningful moments, all linked together. You have been gifted with the innate power of creativity. With practice, you will come to use it every day, in countless ways.

everyday

artful Ideas

FOR YOURSELF

- Look in the mirror, hug yourself, and sing your praises.
- Eat dessert first.
- Give yourself a gift every day: a quiet cup of coffee, an hour's break to read a book, time to sit in the sun, a dish of ice cream.
- Knit a scarf, weave a basket, bead a necklace, draw or sketch a picture.
- Make a daily journal and fill it with the things you love about each day (even if it's only one thing).
- Fill the air with song—play music you love. Dance when the spirit moves you. Sing loudly to the car radio.
- Make a belief book of quotes that reflect your philosophy and inspire you. Illustrate it with magazine images that make you smile.
- Learn something new—a language, a word, a fact about something you have wanted to study. Sign up for a music lesson or pottery class.
- Play! Play cards, play tennis, play just to play, play in your garden, play alone, play with someone. Play for the playfulness of it.

- Wear the blouse that you love (you know, the one your mom told you looks ridiculous). Have fun and experiment with your style.
- Take a bubble bath with a favorite fragrance that relaxes and soothes.
- Escort yourself out for a romantic meal, and write your goals for the coming month, year, and the next five years, while you eat your delicious appetizers.
- Ask questions.

FOR THE ONE YOU LOVE

> Lovers don't finally meet somewhere. They're in each other all along.
>
> —Rumi

- Place a beautiful flower from your garden under the windshield wiper in the morning before your beloved heads off to work.
- Before your honey leaves on a business trip, make envelopes to be opened each day that he or she is away. Fill the envelopes with poems, coupons, IOUs, or simple notes saying "Thinking of you."
- Send an instant message saying "I love you" or "You're sexy" in the middle of the day.
- Bake your soul mate his or her favorite cake on a day that isn't a birthday.
- Make a picnic inside when it's raining.
- Put a little romance in every day.
- Never forget to kiss each other good night.
- Write a poem entitled "The Ten Things I Love about You," and put it in his wallet or her purse or coat pocket where it's sure to be found.
- Go out on a date, be a tourist in your town, and discover new places and faces together. Pretend it's your first date and really listen to each other.

- Write little love notes in your loved one's calendar or BlackBerry, or better yet, schedule a meeting with him or her—and hold all calls.

FOR YOUR FAMILY

It doesn't matter how poor a person is, if he has family, he's rich.

- Place a special note or riddle in your child's lunch box—on a napkin, a decorative paper towel, or write it on the peel of an orange—anything that won't be overlooked.
- Make Friday game night—relax together with pizza and some healthy snacks and competition. Invite your children's best friends to join in.
- Make a family history book using favorite words, photos, and souvenirs.
- Visit a "make your own pottery" place and create a plate for each person in the family, or several pieces to celebrate a special event.
- Turn off the TV and put on your own plays and musicals and share stories.
- Turn on the soothing sounds of jazz and watch your family relax. Make a CD of your family's favorite tunes to be played on long car rides or rainy Sunday afternoons.
- Create new everyday rituals: warm vanilla milk, a story, and a kiss on the forehead before bedtime—special touches that will help your child drift off to a peaceful sleep.
- Plant a garden together, and then watch as the seeds grow.
- Make a video of your grandparents. Interview them about their life and ask the funny questions that will brighten their faces and make them laugh. This project will become a cherished family heirloom.
- Bake together. Make ice cream. Create an Italian feast of fresh pasta, bread, and tiramisu, with a famous aria playing in the background.
- Bring armloads of comforters, pillows, and blankets in front of the largest TV in the house and have movie night, all cozy together.
- Pick your own strawberries and make jam. Enjoy life. It's delicious.

FOR YOUR FRIENDS

A friend is someone who reaches for your hand and touches your heart.

- Craft a mini album/collage brag book for a friend to celebrate a time in her life—maybe she just became a grandmother, or completed a bike tour, or was promoted at work.
- Write a poem to a friend: "When I think of you, I smile because . . ."
- Burn a CD of a friend's favorite songs to play during her commute, or track down the Books on Tape version of a novel she's wanted to read but hasn't had time for.
- Schedule a spa night with friends, or splurge and make it a weekend grown-up slumber party. It's all about the hair, nails, facials, massages, late-night snacking, and laughter.
- Start a "circle of friends" letter. Each person in the circle makes a journal. Begin a letter to a group of your friends. Then send it to one of them—she adds her own letter and sends it on to the next friend. The journal goes around the circle until everyone has written in it and read it. When the book is full, start the next one. Include photos, poems, cartoons, and anything else you want to share. This is an especially fun thing to do among sisters, friends, and family members who live far apart.
- Invite a group of women over to make a recipe book. Everybody brings a dish and copies of her recipe, and then spends the evening sharing her pages to create a scrumptious keepsake.
- Sit together and share a cup of tea. Be together just to be together.
- Invite your friend over for an impromptu breakfast of eggs, toast, and bacon—all cooked by you.
- Set up a "play date" to go shopping, dancing, bowling, bike riding, karaoke singing, hiking, antiquing, champagne brunching, wedding crashing (just kidding), crafting,

to a matinee, or anything else that brings a smile to your faces. Belly dancing anyone?

- Expand your horizons by trying something new together. Discover yoga, volunteer at a shelter for battered women or homeless dogs, become a duet and learn to play the guitar together. Take a knitting class, an African drumming class, a Chinese cooking class. See how far your curiosity will take you.

FOR WORK

If you do what you love you'll never work a day in your life.

- Decorate your workspace with *anything* that brings you joy. A photo of those you love, a painting of the sea, a poster of Brad Pitt, a miniature Zen garden, a low-maintenance plant, a mug with your dog's face on it, a fun screen saver. Or all of the above.
- Remember the power of chocolate. Stash some chocolate in a desk drawer, fill a bowl on your desk with chocolate kisses, or wrap a chocolate bar with a birthday wish to give to a coworker. Remember, a little of what you fancy does you good. And if you want, you're sure to find the tasty nonsugar versions as well.
- Celebrate the people you work with by acknowledging a promotion or a job well done by making a scrapbook as a present, featuring pictures of the gang and congratulations from all.
- Surprise the folks at work with a freshly picked bouquet of flowers for the main entrance of your office, or a small bud or pretty daisy placed on everyone's desk.
- Take turns bringing in breakfast. Even a box of doughnuts is great, and a basket of warm cinnamon rolls or fresh fruit, even better.
- Start a knitting club that meets at lunchtime.
- Turn the music on. Play your favorite tunes at work. Use headphones for a quiet respite, or turn it up when the team needs motivation.

- Play together. Play softball after work; play Scrabble during lunchtime; go bowling in the evening or on a weekend.
- Make a difference together. Organize a neighborhood cleanup; volunteer to help out at a local food bank; help build homes through Habitat for Humanity. Be Santa for the kids at a local hospital during the holidays.
- Celebrate birthdays. Use chalk to decorate the sidewalk in front of work with a big "Happy Birthday to . . ." Hang a poster that everyone has signed. Decorate the birthday boy or girl's office space with balloons and funny toys, and be sure to have plenty of cake and ice cream for everyone.

WHEN SOMEONE PASSES AWAY

Time will pass and sorrow will fade, but precious memories will always remain.

- Plant a butterfly bush or a tree in the honor of the person who has passed on.
- For the service, create a celebratory program with photographs, fun memories, and heartfelt history of a life well lived.
- Send a flowering bonsai tree to loved ones with a note saying, "May this tree be a reminder of the love that will always be in your heart for . . ."
- Write a note to a loved one with a story of how the deceased person touched your life. He or she will be thrilled to know.
- Just be there, even when there's nothing to say.
- Bake your favorite apple cake or chocolate chip cookies to sweeten the days ahead.
- Take as much time as you need to feel the loss and honor the special person who has passed on.

- There are no rules, no right or wrong to grieving. Do it in your own way and trust the process.
- Tell the stories of times shared that brought laughter and joy to life.
- Gather photos into a book that capture special moments in time, or place them in a locket or in a beautiful frame.

FOR THE JOY OF IT

Write it on your heart that every day is the best day of the year.

—Ralph Waldo Emerson

- Play
- Laugh
- Sing
- Smile
- Dream
- Imagine
- Care
- And, wherever you go, go with all your heart.

CHAPTER FOUR

home
is where the heart is

Making Your Home a Reflection of You

every spring my family and I watch with anticipation as a little robin makes a nest in the back of our mailbox. The mama bird carefully carries small branches, leaves, bits of brightly colored string, and slips of paper into the box. With each load of materials, the bird expertly weaves her home. We hope that within weeks we will see little blue eggs tucked inside the nest, and we eagerly wait for the tiny baby birds to emerge. As the hatchlings arrive, we quietly celebrate, so as not to disturb them. A part of our home has temporarily become their home, too, and we strive to make the accommodations welcoming. When getting the mail, we first gently knock so that the mistress of the house has ample opportunity to prepare for unexpected guests. One day I forgot to knock, and the mother bird was so startled, she flew right through an open window into my car and out the other side. (She temporarily and literally flew the "coupe.")

Creating a nest is building a home. Making a home is a universal instinct, a necessity for virtually all living beings: bees do it, bears do it, monkeys do it, butterflies do it, locusts do it, ants do it, foxes do it, chickens do it, spiders do it. And people do it, too.

Animals and insects build and create an array of dwellings, shelters, and homes out of seemingly limitless materials, techniques, and places that support their needs. They sculpt elaborate hives, excavate dark sleepy dens, fashion tree houses high up in the canopy, knit silky cocoons, dig deep burrows, build miniature hills with brown earth, weave beautiful nests, and spin complex webs.

Like our animal and insect neighbors' homes, our human homes reflect who, what, and where we are. Our homes range from cozy, elegant, classic, simple, comfortable, welcoming, and well lived in, to sparse, dramatic, industrial, minimal, exciting, grandiose, and futuristic. The methods of making our homes are as amazingly diverse and creative as the people living inside them.

This chapter shares stories of the simple, daily ways in which people transform their houses into homes. It contains many wonderful reminders that while a house is made of bricks and beams, a home is made of love and dreams. Anything is possible here—no wish too big or too small. Chances are, you've had a lifetime of thoughts on this subject, since from the time we're children, we begin thinking and dreaming about our future abode: "playing house" filled happy hours in our childhood. As adults we can *still* play while acting on those desires, incorporating our current needs, beliefs, values, and fantasies into the mix. This chapter will help you learn how to create the home of your heart's desire through play, imagination, and innovation.

The American home has changed dramatically over the last sixty years. Today, it's unusual to find one that doesn't have running water, a bathtub, and a toilet. But in 1940, nearly half the homes in the United States did not have these amenities. The telephone was a luxury, and it certainly wasn't cellular or mobile. The size of the average house has also increased and is now 50 percent more spacious than in the 1940s.

As we grow and evolve, so do our surroundings. Ideally, our environment should support and uplift us, and offer a welcoming place for family and others who are important to us. As an artist creates a painting, he or she must decide upon the subject, the tints, the mood, and the light. We, too, engage in that same artful process as we build, decorate, live, and love in our homes. This chapter will explore many ways to surround yourself with beauty.

here are over 6.5 billion people living in the world today (in America alone, around 285 million people). Whether high in the Himalayas or on a farm in Tennessee, nearly all of us seek out and require some sort of dwelling, a place to call home. There are big and small houses, some that have stood for centuries, and some meant to be temporary. Some are on land, some are on water. Some are up in trees, and still others are underground. No matter the size or the location, there is no place like home.

A house
is made of
bricks and beams;

a home
is made of
love and dreams.

Most often we think of home as a physical place. We call home a house, an apartment, a mansion, an igloo, a yurt, a tent, a trailer, a houseboat, or even a hotel room. It is where we live, where we can be ourselves, where we are comfortable, where we have a sense of belonging, where we feel safe, where everything is familiar, and where we are part of a family or a community. The word *home* can take on different meanings, depending on your individual circumstances.

Our homes communicate the spirit of the people who live there. Our homes are a reflection of who we are, the place where our story begins and our heart lives. We decorate these physical structures with the things that define us, that we have placed value in, and that we love. Home is where we seek refuge from life's storms. It is where rest, replenishment, and nourishment abound.

In 1956, Tressa "Grandma" Prisbrey, at the age of sixty, began transforming her home and land in Simi Valley, California, into what is lovingly referred to as "The Bottle Village." Initially, as a way to house her seventeen thousand–strong pencil collection, Grandma gathered thousands of bottles (which she had collected from her husband's "bad habit" and also excavated from the local dump) to begin crafting her village. Almost thirty years later, Grandma had completed fifteen structures of her home, including shrines, wishing wells, and winding walkways—all made from found objects she secured with mortar. Her project grew into a labor of love and a way to connect with people. Folks from all over the world came to visit and view her wonderful, whimsical home. Grandma passed away in 1988, but left us with this thought, which really hits home:

Anyone can do anything with a million dollars—look at Disney. But it takes more than money to make something out of nothing, and look at the fun I have doing it.

Today, some Native American Indians still choose to have dirt floors in their homes, as their ancestors did. To them, a dirt floor isn't a sign of poverty, but a very real way to stay close to the earth. The ground represents a way for them to honor their traditions

and beliefs. Many Indians look at the earth as the "mother." They believe that if you cover the mother with cement, you can't feel her, and she can't heal you. They say that if you sit in the home, on the very much alive and powerful earth, you can be energized. You can feel the life energy that emanates from the floor.

Sometimes home is a safe, but temporary place. Remember that in childhood games like hide-and-seek and capture the flag, there was always a certain place where you were safe, where you could not be caught—home base.

Our homes ought to be like that—safe and secure, allowing us the freedom to feel that we can let our guard down, relax, and unwind. Security systems, household dogs, locks on our doors and windows, gated communities, and Neighborhood Watch offer us some piece of mind within our homes. Some folks seek remote, rural areas of the country to put down roots, moving away from cities that often have higher crime rates. Others choose to stay and work within their city neighborhoods to establish activities, shelters, and community centers that teach respect for others and the power of being a good neighbor. There is no right or wrong way to cultivate a sense of security in your home, but it's vital that you find a way to manifest this peace of mind if you are to create a home that truly nurtures you.

The importance of safety and security is clear when women and children have had to move to secret shelters or "safe houses" that protect them from abusive men. Safety is important, too, to the homeless person who finds a cardboard box for cover and warmth in a snowstorm; the family that seeks shelter in a community center during a hurricane; the woman who runs under a portico to escape a thunderstorm—each would call these homes away from home "lifesavers."

The architect and professor Samuel Mockbee and his students crafted houses out of materials discarded by local companies in Georgia for people who lived in poverty and in structures that had failed to provide basic shelter from the elements. Using old bricks, carpet samples, bottles, and used tires, the teams built beautiful, inexpensive homes where families can live peacefully. Mockbee's work has been called "an architecture of decency."

Our homes are a reflection of who we are — the place where our story begins and our heart lives.

Not all homes are built to last, but that doesn't stop them from being safe and welcoming. Mongolian herders, for example, follow their livestock. When the animals move to new feeding grounds and watering holes, the nomads follow. In some months, Mongolian nomads will move every few days. Their round wood and wool homes, tentlike structures called yurts, can be taken apart and moved in mere hours. They're cool in the summer, warm in the winter, and wind resistant. The walls, rafters, and roofing all balance each other, and no ropes or stakes are necessary to hold them up.

Along the Rio Negro and Amazon rivers, where waters rise and fall, some locals build floating houses, which they tie to large trees. This safeguards them against being flooded in the rainy season, and also allows them to have a place to live without having to buy land. These homes are easily sailed out of harm's way and can return when it is safe.

If you've been a college student or sent your child off to college, you know the importance of creating a home away from home. Although temporary (one hopes four years), you fill it with things that are familiar and comforting: old dishes, second sets of sheets, the cozy, faded bath towel with the worn edge, the extra waffle iron you got for your graduation or wedding. You take remnants of the home you shared and help create an environment where you or your child can thrive. You wire up the computer to the Internet, set up unlimited cell phone minutes—all the things that encourage higher learning and a higher sense of connectedness. It's the student's job to add the latest trends in college decor—favorite music, posters, bumper stickers, sports equipment, evidence of club affiliations, photos of friends, and so on. You take heart in knowing that although your child is leaving your nest, he or she is beginning to create an independent life.

Home is a community, too. It's a place where we gather to express and share our common goals. It may be a place of worship, a gym in which to play basketball, a card club, a local diner where everyone knows everyone else and friends gather to catch up, a golf course, the VFW, a civic club, a school, or a community volunteer project. It is where we surround ourselves with the people, ideas, and values that we believe in. It's where we belong, where we take responsibility, have faith, share our stories, help each other, and

cooperate with one another. You know when you have found community because you feel at home.

When neighbors wish a newcomer to their area, we call it a housewarming. Some neighborhoods are active; people know their neighbors and help each other out. Some plant a community garden, and from time to time gather for cookouts and Little League games and block parties. Others are not so active, but the people living there are still linked by their geographic location, if nothing else. I visited a friend in an area of Baltimore where long ago women would wash their white marble steps every day. In the evening, the families up and down the block would perch on those sparkling white stoops, eager to learn the news of their neighbors. Today, crime and fear have pushed many folks in this neighborhood back inside their front doors, but when I looked up at the windows of these row houses, I saw many faces looking out, continuing to watch over their neighborhood.

For the past fifteen years my friend Anita and I have hosted a craft show in the Baltimore area on the first Sunday of December. We first started it in the living room of my house, but the show has grown and grown as we have met more and more people who are making beautiful things. After a few years we began to host the show at our local Knights of Columbus Hall to make room for more than forty artists. Now we invite both seasoned and new artists, chefs, knitters, jewelers, illustrators, ceramicists, and others to exhibit their work. Our holiday show has become a tradition around town, and people come from all over. They meet, visit, share a cup of coffee and a delicious homemade muffin made by Don and Renee, and of course purchase beautiful, one-of-a-kind crafts and gifts. For one day every year a community of people joyfully comes together to celebrate the season, each other, and art.

Recently I heard about a group of women who meet every Saturday morning to cook together and prepare a whole week's worth of dinners for their families. Each woman brings enough ingredients to cook her recipe for her family and for the other women's families, too. If one of the gals is making spaghetti with meatballs she makes enough for all. They put the cooked meals in freezer bags or Tupperware containers ready to heat

and serve through the week. But they also fill their Saturday mornings with talking, sharing recipes, and doing the work that will make dinnertime into a family time.

Before they started this cooking club, all the women described dinner as exhausting, chaotic, and tiresome. Most of the women also worked outside the home all day so coming home to make dinner was yet another chore none of them welcomed. By helping each other, sharing their recipes, talents, and time, these women have created "meals that heal." They're feeding their families in nurturing ways. If community is defined as a group of people with a shared interest, these gals certainly fit this definition.

In Santa Rosa County in northwest Florida, the local folks built a home for their returning hero, Dustin Tuller, a soldier who lost both legs in a battle in Iraq. Hundreds of individuals and companies joined together to build Dustin a thirty-four-hundred-square-foot home to meet his demanding physical needs. Tuller's father is quoted as saying, "People believe in supporting the troops." This town exemplifies the saying "Home is where you are loved."

Community can be made anywhere, anytime people gather for a common purpose. We create communities through our desire to connect. Whether it's bowling every Wednesday night, joining Habitat for Humanity to build homes for victims of floods or hurricanes, meeting girlfriends for lunch, or forming a prayer group to send the healing power of love to a family member recently diagnosed with an illness, the simple truth is, there is no community without *u* and *i*.

Home is also a country. If you have ever traveled and needed a passport, you quickly see that you are part of a bigger home—your country. Some people must flee their country because of war, natural disasters, or persecution. Their safety, sense of belonging,

family, and familiarity are shattered. Home becomes about securing the basics of shelter, safety, and food—keeping the family together and surviving.

In Africa, the women of the Ndebele tribe paint their huts by hand with remarkable geometric patterns and designs. Wives, mothers, and daughters use outbuildings, walls, gateways, windows, and interiors as colorful canvases to express their creativity, identity, and skill. They also create ceremonial beadwork, fabrics, and other adornments to reflect their personal aesthetic. Although they've been driven out of their homes in South Africa, they proudly continue to practice their art. In the past, they painted with organic dyes on animal skins, and now they paint on synthetic cloths with acrylics. They might have been removed from their homes, but no one can take their "home" out of them.

A home can be housed in a company as well. We spend many hours at work, either at the office or in our home offices. Secure, comfortable spaces—and business models that are supportive and inclusive—are at the heart of companies that feel like homes, with staff that feels like family. With little effort and some creative thinking, making a work space that is both private and professional (while inspirational and motivational) can be accomplished artfully.

While visiting a publishing company in New York, I looked down at the carpet and saw that it was cream-colored and filled with words. On closer inspection, I saw that it was the company's mission statement woven within the carpet. Their mission was actually a part of the physical space of the building! It was what anyone who entered stood on and what the company stood for.

One of my sisters works out of her home and has set up her office in a guest bedroom. In a wardrobe that she remodeled, she invisibly stores her business accoutrements, and then like magic (ta-da!), her office appears with one swift opening of the cabinet doors. No one would even guess that the beautiful wooden piece would transform so easily into a full-service workstation with a computer, filing system, and cell phone. Here she works, but she can close off her work and shut it away when she wants to. Because she works from home, office hours could be virtually twenty-four hours a day if she allowed that. Like many others, she pleads guilty to answering e-mails at three in the morning and receiving faxes from overseas at 4 a.m. In trying to manage that delicate balance between work, home, family, and friends, she closes up shop from Saturday morning until Sunday night, and asks that dinnertime be family time. Some days it works; other days it doesn't. As the boundaries between work and home fade, developing creative ways to balance your life and job becomes increasingly important.

I once stayed in a hotel that placed poems on the night table for their guests. The card was in a script font and laminated—nothing expensive, but perfect all the same. Having traveled far and long that day, I was worn out by the time I got into my room. Upon reading the message contained within the little poem, I was touched to have received such a gift from someone (or more exactly some organization) I did not know. It was a sweet reminder that we are all in this together. Here is what was printed on the card:

To Our Guests

In ancient times there was a prayer for "The stranger within our gates."

May this room and hotel be your "second home." May those you love be near you in thoughts and dreams. Even though we may not get to know you, we hope that you will be comfortable and happy, as if you were in your own home.

May the business that brought you our way prosper. May every call you make and every message you receive add to your joy. When you leave, may your journey be safe.

We are all travelers. From "birth till death" we travel between eternities. May these

days be pleasant for you, profitable for society, helpful for those you meet, and a joy to those who know and love you best.

Home, too, is a place within you. It is a feeling of security, soul, familiarity, comfort, care, and belonging. It is always present, a place of shelter from life's chaos and storms. As Emily Dickinson wrote with great understanding, "Where thou art, that is home."

Julia Butterfly Hill made her home atop an ancient, thousand-year-old redwood tree for two years, starting in December 1997. The then twenty-three-year-old climbed to a small platform 180 feet above the ground, and lived there to protect the giant tree from being cut down. There, she housed her beliefs. During her 738-day stay, she received international publicity, entertained celebrity visitors, and conducted hundreds of interviews and news conferences. Her individual protest attracted more attention than any other environmental demonstration led by the thousands of activists who had fought for more than a decade to preserve ancient forests from being logged. Her actions helped to facilitate the successful negotiation to protect the tree permanently, as well as its nearly three-acre buffer zone. Julia reminds us that, "By standing together in unity, solidarity, and love, we will heal the wounds in the earth and in each other. We can make a positive difference through our actions."

My own house is full of people, animals, color, and art. I share it with my husband, Mark (an artist), daughter Hannah, fourteen chickens, two dogs (Buddy and Matilda), two fish (unnamed), and a cat called Emily. My studio and company are also in our home, with four staff, delivery folks, and a constant stream of visitors. It's cozy, ever growing, always changing, and certainly well lived in. It is a place of comfort. We have fun there. Our home tells a story, our story. Our furniture is often recycled and handcrafted, and if the pieces could talk, they would surely have a tale to tell.

During a neighborhood cleanup, I unearthed eight rusty springs from an old mattress. I dragged the mattress to the truck for the dump, but began formulating plans for the springs I'd saved. Back at home that evening, I affixed them to a base made from a piece

of old wood and put a white pillar candle in each one. I smiled with pride as I lit our striking new dining room centerpiece.

As my passion for making art has grown, so has the physical space that houses my supplies and nurtures my creative spirit. My studio has moved from the dining room table to the basement, to the garage, to an old bee farm, to a building that now serves as my creative retreat. When I first started making pottery I covered the dining room table with newspaper and started painting. I unplugged the dryer and plugged in a small kiln in the basement. I made do with where I was and what I had. I learned that I didn't need a special place to create. The wonderful thing about being creative is that you can do it anywhere.

But I quickly came to see that I needed room to spread out and store my growing piles and kinds of supplies. Today my studio has a wall of shelves filled with hundreds of glass jars of various sizes to hold the multitude of beads, buttons, yarns, stones, paper scraps, sea glass, paint, brushes, charms, glue sticks, and other things that I find beautiful and might someday want to use in my art.

I also created an inspiration wall for myself. I strung wire between two screws drilled about fourteen inches apart on the wall. I basically covered one entire wall with parallel wires. Anytime I see an image, a color, a pattern, or discover a quote, a poem, or am sent a letter that touches my heart I hang it on one of the wires with a clothespin. All I have to do is look at my inspiration wall to give me a spark that starts my creative energy flowing.

My studio has a large table in the middle of the room that is the perfect height for me to stand at and make art. The table is covered in paint, glue, and other evidence of past projects. I think that it proudly wears its history (and mine).

Wherever you are when you engage your creativity, you set into motion a powerful process. This creative process is not mysterious, but you'll find different ways of catalyzing your own process, which will probably have different stages than mine. But to give you an idea of how I follow a creative idea, for instance, I basically go through four stages. When I'm in my studio and I want to create something, first, I see it in my mind's eye. I actually call this first phase *seeing*. This is when I envision, identify, and define what I

wish to create. It could be a ceramic plaque or serving platter with a message in its design, or a piece of furniture, or some baby clothes. In many ways this first phase helps me set the course, establish goals, and direct my creative ideas to becoming real, physical.

Once I see where I want to go with an idea, I then begin to pull from my wall of supplies the things I need to manifest my vision. I call this second phase of my creative process *gathering*. Curiosity, discovery, and imagination define the gathering process. Sometimes I don't have the materials I need to complete a certain project, so I begin to search for just the right material to bring my idea into reality. Finding just the right material—whether it be the right bead, button, thread, or piece of paper—has taken me on many adventures. Sometimes the search takes me just outside my front door; other days it leads me to the local bead shop, or yarn or antique store; once it took me as far as New York to look for the perfect fabric for a line of pillows. No matter where the search takes me, though, I always meet wonderful people who have taught me much about the materials they sell or make.

After I've gathered all the materials I think I need to manifest my vision, I begin the next phase of creative thinking, *arranging*. In this stage, it's important to play and experiment with the materials and ideas. I solve problems and work through the consequences of the earlier decisions and choices I've made, the shapes I'm working with, the combination of colors I want to use. I arrange and rearrange things until I feel satisfied with what I see. Ultimately this phase is about deciding how all the elements can work together and what techniques will work best to achieve my vision.

The final phase I call *doing*. This is when I use, assemble, and complete what I have gathered and fully manifest my vision. As I work I have even more fun than in the earlier phases and feel a sense of accomplishment as I move toward making my new creation.

Each of us uses a similar process as we use our creative energy. The best thing about making something is that this creative process often sweeps you up and energizes you and at the same time gives you a sense of calm, well-being, and happiness that grows along with whatever you are creating.

To nurture your own creative process, make a studio space for yourself. It can be your

kitchen, where you can house all the materials and tools you need to create delicious food. It can be a garden shed where you stock seeds, mulch, and pots for growing a variety of beautiful flowers and vegetables. It can be in your basement or garage where you can make a workshop filled with saws, drills, nails, and pieces of wood you've culled from old buildings. Or if you already have an extra room in your house, maybe a guest bedroom or old pantry or utility room, you can load it with baskets of yarn and knitting needles, some shelves, and wall hangings.

Some people find that they need to have quiet in order to be creative; for others, music serves as inspiration and keeps them moving and focused. There are no rules. Enjoy the process of discovering and identifying the things and space that you need to support you as you create an environment where creativity can flourish.

he mantle in our living room is made from an old car bumper, and the base of our dining room table was fashioned from parts of several bikes—including the frames, and even pedals that still spin. My daughter's bed canopy used to change weekly, as she would find flowers, feathered boas, and vines to weave into the tapestry that hung above her head. Today, she collects old plates with flowers on them from flea markets and yard sales, and we hang them behind her bed, creating a sort of garden of pottery. She also has a wall covered in chalkboard paint, allowing her to write her favorite lyrics from a song, sketch an image, or leave coded messages to a girlfriend who is spending the night. From time to time, I still write quotes on the wall that I hope will inspire and interest her.

We fill our home with photographs of people who have touched our hearts and of moments we have shared. Our friends and their families have crafted many of our wall hangings and artwork. In every season, we fill the house with flowers because we love them. In wintertime, we grow grasses in large boxes so that we can feel the abundance of nature around us throughout the year.

When my daughter was six, she, her dad, and I created self-portraits on hearts cut

from plywood. We took water-based acrylic paints—nothing fancy—and had the best time painting pictures of ourselves. We proudly displayed these paintings on our living room wall. They are still priceless masterpieces to me.

Our front porch is home to things I find on my walks. Lately, as I walk in the woods, I've found branches, round nests, seedpods, and vines that look like letters in the alphabet. I discovered LOVE the other day: L, a seedpod; O, an abandoned bird's nest; V, a bent branch; and E, a torn maple leaf.

Mark and I bought our home fifteen years ago. Thinking we were pretty handy, we planned to do all the renovations ourselves. Eager to start right after the closing, we drove straight to our new home and immediately ripped up the old carpeting, revealing plywood subflooring. We then headed to our local carpet store to purchase new carpet. We gave the clerk the measurements of the floor, and he gave us a price that made our heads spin. We quickly learned that we couldn't afford to recarpet our new home.

Feeling a bit shocked (okay, a lot shocked) we headed back to the house. We sat on the floor (as we had yet to move in any furniture) and began brainstorming about how we could "fix" our floor. We decided to recall the kinds of flooring we had seen that we really liked. We each searched our imagination and memory for things that caught our eye in magazines or in friends' homes. We both liked hardwood floors; we liked poured cement floors; we liked woven rugs with beautiful floral patterns; and we liked the country homes that had painted floors. I had seen painted large canvas floor cloths that had been covered with many coats of varnish to create artful and durable rugs for a foyer. Ah-ha! Until we could afford the large wooden planks, why couldn't we paint our subflooring with paint in any pattern we liked, and then cover it all in varnish? The answer, of course, was that we could.

The next day, we bought gallons of blue paint and covered the floors with the base coat. I then painted large pink roses with green leaves on top of the blue. Before we knew it, our rooms were covered with a carpet of roses. Many coats of varnish later, we had a durable surface for our floors. Years later, when we could afford the wood floors, we covered up most of our hand-painted creation—but we kept the powder room in flowers for several more years.

Does your home reflect who you are and what you believe in? Does it provide a place of shelter, safety, and a sense of belonging? Does it reveal your style, your values, your passions? Does your home provide a place to rest, relax, and nurture your spirit? What does your dream home look like? If you answer "no" or "I don't know" to any of these questions, don't worry. Visualizing your ultimate home is within your reach, and it costs nothing but the price of your imagination.

Try to see your dream home in your mind's eye. Visualize the details, and focus on the elements that make it your own space. Look through magazines and pull out pages of rooms you like, as well as colors, furniture, arrangements of collections, flooring, and other details that capture your fancy. Glue or staple these images in a book as an easy, entertaining way to begin to assemble a picture of the physical home you want to create. Jot down notes in your "home book" of things and ideas you see while traveling or visiting friends' homes.

Don't just fill the book with ideas—fill your world with them. Try painting a mural in your baby's room; cover your dining room chairs with bright red fabric; paint a set of dishes at the local paint-your-own pottery store; change the knobs in the kitchen with different funky patterns; sew curtains for your powder room from cheeky embroidered hand towels that sport quotes like "I am a marvelous housekeeper; every time I leave a man I keep his house" (Zsa Zsa Gabor) or, "A clean house is the sign of a wasted life." Hang colorful beads from your dining room chandelier. Plant herbs in pots and place them in the window in the bathroom so when the air fills with steam, the room is perfumed with rosemary and lavender. Fill your home with the sweet smell of an apple crisp baking in your oven.

Surround yourself with the things that reflect who you are. Share, display, and decorate with the things you value and love. My friend Judy and her family love winter sports. Judy hung an old red sled horizontally on her living room wall, with a pair of antique ice skates dangling from the runners. She says that just looking at it makes her happy.

A couple I know enjoys displaying their Roseville pottery in their front entryway, changing the pots a few times a year to harmonize with the colors of the seasons.

A friend of mine is inspired by quotes from famous women. She writes them on Post-it notes, and whenever she finds one that she loves, she places the quote on the bathroom mirror. Each morning, she is greeted with ideas, inspirations, and thoughts with which to start her day.

A woman I know stenciled her favorite words around the border of her living room, including *live, love, laugh, dream, imagine, care, believe, create, celebrate,* and *dance.* These words repeat in white paint on the latte-colored paint encircling her living room. She considers them words to live by.

I read about a couple that loved wine and wine labels and began to decorate with them. They carefully pulled the labels off hundreds of bottles, and so did their friends, family members, and even neighbors. Once they had enough labels saved, they affixed them to the wall in their powder room with glue and added a coat of varnish. These labels formed a mosaic of color, a unique, imaginative wallpaper.

Another couple I heard about collected matchbook covers from restaurants and hotels throughout their travels. When the wife died, her husband wallpapered her sewing room with those covers as a memorial to her, and to honor the many treasured times they shared.

Create a home that is comforting and nurturing. A woman I know created an oasis for her husband following his surgery for acute appendicitis. Home from the hospital, weak and in constant pain, he was on bed rest for eight weeks, and spent day after day staring at a boring blank white wall. He missed the outdoors and longed to be well enough to return to his active lifestyle. His wife wanted to aid in his recovery, to help him feel better, and to add a little color to his now fairly drab world.

One morning, while a friend drove her husband to the hospital for a checkup, this woman painted the white wall a beautiful sky blue. She had never created a mural before; she didn't know exactly how to do it, but she just began. She knew her husband would be home in four hours, and anything, she reasoned, was better than what had been there before. She painted white puffy clouds on the blue surface, then black birds—not much more than a handful of V-shapes—and two hot-air balloons in the foreground to finish off the scene.

The man and his friend came home and were astonished at the wife's creativity. No one knew she had it in her. But she had transformed the wall into a true work of art, making everyone who saw it smile. Her husband said that looking at it made him feel like he was outside again, enjoying the ease of a summer day. She liked to think it let him know how much he was loved.

Create a cozy nook in a bay window and line it with pillows for comfort, along with several books that you long to read. Throw big pillows on your sofa, and watch how the feeling of the room changes with the colors of the season. If you have a fireplace, use it! Make a roaring fire and have dinner in front of it, or simply place a few pillar candles and light them for a soft romantic glow. Make every room in your house comfortable, livable, and relaxing. Instead of waiting for company to use the formal living and dining room, use the fancy china and the new sofa and chair. Treat yourself and your family like pampered guests, and enjoy! Nurture yourself; draw the curtains and a bath; light a scented candle and turn on your favorite CD; cuddle up on an overstuffed chair with a throw and read a good book; sit in the window and allow the sunlight to warm your shoulders as you read the morning news. Fill your home and surround yourself with comfort.

Create a room for quiet and rest. It can be a small space in the attic, a corner of a room, a small closet (or a big linen one), a second-story loft, a private room, or even a spot hidden behind a shower curtain. The point is to keep noise out and quiet in. One of the great Western teachers of Tibetan Buddhism, for instance, lives in a New York apart-

ment and doesn't have much space, so he converted a coat closet into a shrine and meditation room where he practices and chants every morning. He hung a beautiful, multicolored silk tangka, or religious art tapestry, on one wall, and has a small table on which to put devotional objects. It is a lovely, simple, but inspiring sacred space.

You can create such a space in your own home and spend time meditating, breathing, and being in this place. Allow calm, restful, relaxing thoughts to fill the space. You know when you need to have a conversation with yourself? Sometimes in your busy day, you just can't hear yourself think. A quiet room is the perfect spot for this. It doesn't matter where you create your special space, as long as you make it a place you want to be. I've seen these rooms made to be cozy, with big pillows, blankets, scented candles, incense, and soothing music playing, and I've seen them more austere, with a meditation pillow and little else. Create whatever works to help you gain your center, find your calm, and get some peaceful "you time."

Create a home that extends outward past the boundaries of your walls. Allow your home to reach out into the yard and embrace the beauty and gifts of nature. Create a garden, plant some seeds, perhaps daffodil bulbs or wildflowers. Hang wind chimes from the nearest tree to your bedroom window, and listen as the wind plays a melody. Arrange chairs and a table in your yard, and serve dinner outside by candlelight. Plant a hedge of lilacs around your patio and wait for spring to fill the air with their intoxicating scent. In the fall, take a ride to see the leaves change from green to orange to red. Fill a paper bag with colorful leaves that have fallen to the ground. Load the backseat of your car with pumpkins and mums from a local farmer. When you get home, arrange the leaves on a large platter (maybe the one you serve turkey on), put the pumpkin in the middle, and place the mums to the side. You will have just created a beautiful seasonal centerpiece.

I know of a man who lives in the mountains of the Southwest who loves to garden, but with so many wild animals on his property, he finally gave up, saying that he was tired of fighting "hungry everything." Instead of building elaborate fences, the man decided to

bring part of the garden inside. Using a large south-facing window in his family room, he planted cherry tomato and basil seeds in pots on a bench in front of the window. Soon enough, the plants grew to the ceiling (helped along by thick twine) and were so plentiful and delicious that neighbors made their own indoor gardens the next year. Essentially, the man had made a greenhouse out of this one room, and his children, especially, took great delight in Dad's creativity.

My friend has created a beautiful outdoor sanctuary. He loves the gardens of Italy and has incorporated many of those aesthetics into his own. He works the soil, pulls the weeds, and plants the seedlings with great care. When he comes back into the house from working in his garden, he glows and says, "I feel alive and at home out there."

Create a secret garden, a piece of land you can call your own. It can be a place where butterflies flock, where only yellow flowers bloom, where flavor-enhancing herbs thrive, waiting to be savored in your recipes, or where you sculpt boxwoods into topiaries of swans and hearts.

I've always wanted to see a place in Chandigarh, India, called The Rock Garden. The creator, Nek Chad, was a road inspector for the department of public works in northern India. After work, he began to build a secret place, a rock garden deep in the forest of a preserved land area. He worked and played there for forty years, using urban and industrial waste in what would eventually cover forty acres with sculptures, mosaic walls, paths, and trails. This heartwarming secret garden is now India's second largest tourist attraction after the Taj Mahal.

Mr. Chad was motivated and fascinated by the concept of creating "something from nothing." "It really began as a hobby," he said. "I started not with the idea that I would become so famous. Every day, after I finished my government job at five, I would come here to work for at least four hours, as I did on almost every holiday. At first my wife didn't understand what I was doing every day, but after I brought her to my jungle hut and showed her my creation, she was very pleased."

One day I was looking out my bedroom window, and my eyes fell on an old white-washed picket fence we had lying against our shed. I imagined faces within the weathering

It doesn't require a lot of money to make a home; it takes a lot of love.

of the individual pickets (like when you see the face in the moon) and they looked like angels to me. "There are angels dancing in our picket fence," I said to my husband. "Show me," he said, as he brought some of them inside. I spent an afternoon making them into garden angels by attaching a small piece of tin roofing material as wings to the back of the picket, and painting simple faces on the front. What treasures could you have just waiting to be discovered around your backyard?

Create a place in your home that feeds both the body and the spirit. It has often been said that the heart of the home is in the kitchen. People gather there more than any other room, in part to nourish the body. Along with our bellies, our spirits are fed there, too. Warmth and aromas from the stove provide comfort and contentment. I often sit in my kitchen with a friend, drinking tea, and working out a problem in this spot. It's also where I learned to make fried chicken with my mother, as she shared the stories and lessons of her life. It's where I taught my daughter how to use a measuring cup and to count on herself, and where I've spent many hours alone, sipping a cup of coffee as I greet the day and myself. If you search your memory, you, too, will find delicious moments spent in the kitchen with family and friends. Savor those memories and bake up a few more.

I have come to realize an important fact about myself: I don't eat to live, I live to eat. I have also come to understand that I am not alone in this. The foods, family recipes, traditions, comfort foods, and culinary delights we share with one another add flavor to our memories, and help to make our lives delicious.

When I explore my memories of meaningful times, it is hard to not think of the food that was served. When I think of people whom I love and who have enriched my life, I often think of the moments and foods we shared. It seems that food and memories are as linked as hot dogs and ketchup, salt and pepper, and strawberries and cream.

When I was a child, my mom made chicken fricassee with dumplings. This delicious dish of chicken and gravy served over white rice with huge flour dumplings was my

favorite dinner. I confess that it still is (forgive me, Dr. Atkins). Chicken fricassee with dumplings was not reserved for special holidays or birthdays—not this warm, delicious tummy filler. No, it was served often at our home. I will always cherish my memories of all nine of us around the kitchen table passing mile-high bowls of dumplings.

My sisters and I were recently talking about our favorite foods that Mom made when we were growing up. I had mistakenly assumed that chicken fricassee with dumplings was everyone's favorite, but we all had different ones. Karen loved Mom's chocolate cake with three-minute icing. In our homes, it simply is not a birthday without that chocolate cake with white icing. Donna loved grasshopper pie. (There are no actual grasshoppers in this pie, but crème de menthe gives it its green coloring and its name.) Lisa loved the shrimp dip Mom would make on Wednesdays, although we were only allowed a spoonful of this delicious treat, as the rest was reserved for her bridge club later in the day. Susan loved Mom's chocolate chip cookies made by the bucketful at Christmas, and cleverly hidden so that we would not eat them all before our guests arrived.

There are so many ways to bring meaningful moments into your home. Stop and have dinner at night with your family. This is the chance for everyone to come together at the end of the day. Catch up. Take time to ask questions. Make a plan for tomorrow. Have fun. Maybe break up the daily routine by having each family member find a new word, requiring that he or she use it in a way so that everyone can try and figure out what it means. Take turns making dinner, encourage everyone to serve what he or she loves to make. Do the dishes together; the work goes a lot faster when shared, and these moments offer precious time in which to be with the ones you love.

I saw a woman interviewed on the local news who said that when her neighbor the baseball player Eddie Murray hits a home run, she starts baking a pie so she can leave it on his front steps when he returns home. It's her way of saying, "Great job."

I know a woman who makes the most incredible carrot cake. Cream-cheese icing, freshly grated carrots, and lemon zest make this cake a melt-in-your mouth masterpiece. She doesn't make it often, and she only makes it for people she really likes, so when she gives away this treasure, the person really knows that he or she is loved.

When your

with friends

and conversation

when handshakes

given with

house will have

dwelling fills
and family,
fills the air,
and hugs are
abandon, you
become a home.

When you enter a house that is perfumed with the aroma of dinner cooking in the oven, the warm scent of cookies baking, or the sweet smell of apple cider warming on the stove, you are transported to a place of satisfaction and delight.

I can't count how many moments I've spent with the "women of the house" in the kitchen, as we prepare food to honor a special someone or to commemorate an occasion. We meet with the intention to cook, of course, and eventually we get to that, but we have other business to attend to as well. First, we share the latest news about our children, and then we go on to discuss our husbands, talk about our work, vent our frustrations, express our concerns and fears, console each other, challenge each other, inform each other about sales and events, and celebrate the suspicions and announcements concerning a possible new baby on the way. We laugh, and some days we cry. We share recipes, tips, and gossip as we pass on family traditions, rituals, and the art of friendship. We don't realize it at the time, but together we're creating memories to be cherished, for both our families and ourselves.

ome is a little word with only four letters, but it affects our lives in a huge way. Creating an artful home requires that you find and celebrate you, show your style, play, experiment with color, decorate, embellish, try new things, do tried-and-true *old* things, establish traditions, make mistakes, plant a garden or just a seed, embrace comfort, insist on safety, cultivate kindness, bake up a treat, treat your guests like royalty, work at play, play at work, express yourself, rest, relax, and put your feet up. By putting your heart into your house with attention, desire, and care, you create the home of your dreams.

When your dwelling fills with friends and family, when laughter and conversation fills the air, when handshakes and hugs are given with abandon, your house will have become a home. Welcome home.

Artful Ideas for the home

ARTFUL WAYS TO DECORATE

> A house is a home when it shelters the body and comforts the soul.
> —Phillip Moffit

- Make a quilt using all the fabric that you've got around the house that's not currently in use—you know, the material from clothes that don't fit, old ties, baby clothes, or worn or outdated blankets. I bet you have loads of pieces, if you just take the time to look. Cut them up into six-inch squares and stitch them together to create a quilt that will surely cover you with well-worn memories.

- Create a family portrait wall by applying photographs to plates. Purchase transfer paper at your local craft store and glue your loved one's images in the center of a plate. Hang with plate hooks for a personalized wall of fame.

- Use clear or light-colored empty wine bottles as picture frames. Clean the bottle with soap and water and let dry. Decide on an image you want to frame, cut it to fit the lower part of the container, and carefully roll it into the bottle. Release the paper and allow the image to unfurl inside. Because the bottles take little space, it is fun to fill a mantel or a shelf with many of these artful frames.

- Use your favorite essential oil placed on a lightbulb to infuse the air with an intoxicating aroma. A tiny drop of rose, lavender, or vanilla oil can be gently rubbed on a

cool lightbulb. When you turn the light on, the warmth of the bulb activates the scent to gently fill the air.

- Make pillows with photo transfers. Use your favorite quotations, photographs, fancy buttons, and/or trim to decorate each unique work of art.

- Make candles with family or friends' pictures on them. Glue the image onto the outside of a candle, and wrap with a ribbon to make a perfect display on the mantel, or give as housewarming or hostess gifts.

- Craft a wreath for your front door from things you find in nature. Use a basic wreath form (purchased at your local craft store, or make one from wrapped wire). Attach things you find and love with bits of ribbon and hot glue. Branches, nuts, acorns, leaves, berries, and dried flowers make beautiful materials to add to your festive wreath.

- Fill bowls with seasonal fruits and vegetables to create colorful and inexpensive centerpieces. Apples and walnuts, persimmons and pomegranates, and lemons and limes all provide bright dashes of color that brighten any home.

- Hot glue your favorite-colored ribbon onto plain white lampshades to create artistic lighting anywhere. You can also glue stamps, adhere beautiful papers, or rubber stamp words on the surface of the shade as well.

- Set up a message board—either a chalkboard, cork board, magnet board, or other—for family members to display inspirational quotes, jokes, cartoons, and so on. You can make a stack of quotes ready to hang when the spirit moves you.

- Create a portrait gallery—have favorite family photos transferred onto canvas, then frame them like paintings. You can purchase transfer paper at a local craft store. Or, have each family member paint his or her own self-portrait.

- In the kitchen, change old cabinet knobs to fun, varied ones.

- Create index cards with the history of a piece of furniture that has been passed down to you. Place the history card in a drawer, under the table, or in a seat cushion so that when you hand it down, the lore and history are transferred.

- Create a revolving art gallery in your home of your kids' work. String wire between two hooks and hang the art with clothespins.

- Put together shadowboxes filled with memorabilia from fun-filled vacations.
- Make a spalike scenario in your guest bedroom. Fill baskets with magazines, shampoos, lotions, a bowl of fruit, and candles for when your treasured guests arrive.
- Unearth the things you collect out of boxes you're storing them in, and arrange them by color or style—a creative way to share with others what you most love. Whatever you collect—ceramic figures, baseball cards, buttons, thimbles, guitars, teacups, or sheet music—create a special place of honor.
- Make wallpaper out of your favorite paper or fabric. Wallpaper a sewing room from old sewing pattern tissues. Cover a wall in a children's room with pages from a book of nursery rhymes. Or use fabric swatches to create a crazy quilt wall in your laundry room.
- If you know how to knit, go to your local craft store and buy beautiful yarn in a color you can't resist, and knit a handmade blanket. If you don't yet know how to knit, you can learn—it's easy!—and make this project in a weekend. Knitted throws are wonderful to wrap up in as you sit and read a book, take a little nap, or watch a movie on fall nights.
- Paint a room red. Use favorite colors to define spaces and moods throughout your home.

ARTFUL IDEAS WITH FOOD

Cooking is like love. It should be entered into with abandon or not at all.
—Harriet Van Horne

- Make yourself a candlelit dinner and break out the special linens and china. Treat yourself as a guest in your own home.
- Make every Thursday night "Finger Food Night," with bowls of chips, salsa, guacamole, popcorn, crackers, cheese chunks, baby carrots, olives, and anything else your family adores.

- Create a baked-potato bar right in your kitchen, complete with bacon bits, sour cream, grated cheddar, onions, and salsa. Or a taco bar, with ground turkey (or tofu), shredded lettuce, cheese, diced tomatoes, avocados, and cilantro.

- Make your own salsa. This is so easy and fun, and makes great gifts.

- Make chicken soup. Fill a pot with water, chicken, and anything else you want to make a comforting delicious work of art to share with friends and family. Remember you are an artist and anything you make is a work of art, even chicken noodle soup!

- Have a "make-your-own" pizza night, where everybody in attendance gets his or her own pizza dough and can choose from a cluster of toppings.

- Invite neighbors over for dessert night, with different flavored ice creams (and fruit, nuts, and candies to mix into the bowls). Don't forget vanilla!

- Visit your local farmer's market and shop for seasonal vegetables, fruit, and home-grown goodies. Plan your menu around the natural harvest: butternut squash soup in the fall, spicy black bean soup in the winter, fresh spinach sautéed with garlic and pancetta in the spring, and tangy steamed shrimp with lemons in the summer.

- Place a batch of freshly baked cookies in a brown paper bag and tie with a beautiful red ribbon.

- Make a Sunday brunch—a wonderful relaxing way to entertain. Serve a frittata with a medley of fresh vegetables and cheese, roasted potatoes with rosemary and garlic, grilled sausage with fresh fennel, and corn muffins with strawberry jam.

- Chill out: there's nothing like the natural sweet tastes of nature to satisfy your hunger and sweet tooth, while providing nourishing snacks. Make grape snowballs: put freshly cleaned bunches of seedless grapes in plastic bags in the freezer. When frozen, they're such a treat! And, for the best-tasting smoothies (with the consistency of ice cream), try putting your ripe bananas in the freezer. When you're ready, drop them, skins and all, in a bowl of warm water. Within a few minutes, the skins easily fall off, and it's time to throw the frozen bananas into the blender with a small amount of juice or water, and voilà, you've got a delightful and refreshing breakfast or dessert!

- At dinnertime, turn off the TV. Make dinner together as a family, or carry out Chinese. Stop for an hour and catch up. Nurture your body and spirit with the people you love. Catch up on the day, plan the next one, talk about nothing or everything. Above all, savor the moment and each other.
- Go on a picnic. Pick a sunny day and pack a basket with snacks, sandwiches, chips, and sodas. Invite a few friends to come along. Pack a cheese spread, with grapes, gourmet crackers, and your favorite wine. Throw a blanket on the ground in a park, at the zoo, or by a lake. Relax, read a book, take a nap, play catch, sketch the scenery, or take a walk.
- Keep on hand in your pantry the few ingredients you need for tapas. Making and serving these "little dishes" to be shared by all is a wonderful way to get to know folks at a party. Make bruschetta; tapanade with goat cheese on crackers; hummus with pita chips; artichoke tarts; Brie cheese in pastry with mango chutney.
- Learn to make at least one fabulous dessert: cheesecake, rhubarb crisp, brownies, crème brûlée, or English toffee.
- Be known for a dish: Molly's famous apple pie, or Susan's world-renowned hummus. Make something that you love and that others will love you for.
- Go to your local festivals and taste the different cuisines being celebrated. Some of my favorites include: the Greek festival at the Greek Orthodox church; the Italian supper, held in the basement of the Catholic church in our town's Little Italy; fabulous chicken barbecues at the VFW (Veterans of Foreign Wars) that raise money for their activities; and ham and oyster suppers that the wives of our volunteer fire company put on to fund repairs at the fire house. There are strawberry festivals in the spring, and harvest festivals in the fall. Keep an eye out for listings of these types of events in your local paper or grocery store flyers. Or, get the family into the car for a Sunday drive and see if you can't find some church or fire hall that's in the festive mood. These excursions are a fun way to explore new things, and they're often a bargain, too!

ARTFUL GARDENING IDEAS

> Let each garden be different and unique, as is each soul. Man's trend should be to unity, not uniformity. Each to his own talent.
> —Dorothy Maclean

- Instead of potted plants, make little herb gardens to serve as dining table centerpieces. Or use glass bell jars as terrariums.
- Cut a heart shape in the lawn using a mower.
- Plant a garden with butterfly bushes and enjoy the visits of hundreds of butterflies.
- Make a garden pathway using stones you craft with cement. Pour the cement in a box of the size of the desired stone, and place objects like shells, sea glass, and mosaics in the wet thick mortar. Carve your name with a stick, or even stick in your bare foot to make an imprint before it dries.
- Plant lots of red tulip bulbs in the shape of hearts in your garden so that in the spring, your garden will blossom with love. Secretly plant a heart tulip bed in your neighbor's garden.
- Pick a handful of pansies from your garden and tie together with a velvety purple ribbon to give to a neighbor.
- Hang several hummingbird feeders outside of a main window, and watch as the birds joyously flit back and forth.
- Build a koi pond and fill it with colorful fish.
- Make feeding balls for birds. Simply spread peanut butter on an orange, and then roll it in birdseed. Hang these beautiful balls from branches and watch as the birds enjoy the bounty.
- Learn to build (or have built) a water garden and transform your yard into a babbling brook.

- Add elegant and colorful pinwheels or figurines to your garden.
- Plant a miniforest of large sunflowers, and when their stalks grow tall, walk into the magical thicket. Allow the flowers to dry in the sun and hang as bird feeders from the trees in the late fall.

ARTFUL WAYS TO ORGANIZE

Anyone can make the simple complicated. Creativity is making the complicated simple. —Charles Mingus

- Use large glass jars to showcase collections of buttons, seashells, matchbooks, colored candies, herbs, dried flowers, pinto beans, oatmeal, pasta—anything pleasing to the eye or stomach.
- Save the ribbons from every present you get and store in a big glass jar. Use them over again to tie everything up with beauty from flowers, to curtains, to napkins, to hair, to a blouse, to a bag of jellybeans.
- Hang a row of coat hooks on your bedroom wall on which to arrange bracelets and necklaces. Your pieces of jewelry are works of art—display them as if your room were a gallery. Or, using an antique frame, tack a piece of wire mesh across the back to create a holder for your earrings.
- Create the "door of fame" for your family and friends to enjoy when they visit by making magnets from vintage buttons for the refrigerator door. Each finely crafted magnet will hold in place an equally beautiful photograph of a cherished person, place, or memory.
- Hide your valuables or store things in small, whitewashed birdhouses, displayed up high on a top shelf (choose the kind where the roof comes off for easy access).

- Buy small, matching frames for a mantel, and fill them with cherished family photos. Or collect frames only in the shape of ovals to create a well-rounded photo collection.
- Invite a little of the outdoors inside by bringing in terra-cotta pots of different sizes into your home. Use in the office to hold pencils, paper clips, and rubber bands. In the bathroom, a simple coat of varnish in the interior make these containers ready to hold cotton balls, Q-tips, toothbrushes, and soaps. Add a piece of oasis (green spongy stuff bought at floral stores) and fill with fresh cut flowers.
- Get a wooden CD holder, the kind with square shelves (six or nine compartments) and display colorful ceramic bowls in the squares. The bowls not only look beautiful, but they're a perfect place to store jewelry, coins, keys, buttons, hair ties, bobby pins, or anything else that's small and needs organizing or safekeeping.

ARTFUL IDEAS FOR THE OFFICE

Home is where my computer is.
—Linda Sivertsen

- Use a folding screen made from old doors, shutters, or windows to block off an area just for your office.
- Make bookends out of recycled architectural elements. The top of a column, antique door stops, jars of buttons or coins, or garden statues (I love the cement ones that look like elves) will hold your books in place artfully.
- Organize your bookshelves in order of size and topic—not only will they look beautiful, but also your books will be easier to find.
- Tie thank-you notes and letters that you have received in bunches, with a beautiful

silky ribbon. Store them in bundles on the bookshelf. Or, paint a mailbox and bring it inside. Display it on a shelf (perhaps as a creative bookend), and put the letters inside.

- The most artful paperweights I've seen are made from rocks painted with the art from children. Collect rocks (smooth ones) and ask your kids or your friends' kids to paint a bunch with acrylic paint. Varnish when the image is dry and you will have amazing art (to keep or to give) that I guarantee will be worth more than its weight, and will help keep an office area organized in heartwarming style.

- Make a frame by gluing words or quotes cut from magazines to plain wood frames (you can find these at local craft stores). Apply a coat of varnish on your finished art to seal. Display any reviews, awards, or "wins" from your work in these fun frames.

- Post an artful outgoing mail basket on the wall in which to store letters and bills: an old bicycle basket, a wire egg basket, an old sap bucket from Maine, or a wicker container.

- Create collections of your favorite colored rocks or shells in the windowsill, or by your phone, for easy viewing and holding.

- Install a small water fountain or sound machine in the corner, to give you the sense of a calming environment.

- When you're organizing, have soothing music playing in the background (Mozart is good for the brain), or turn up sounds that energize and motivate you to get the job done.

celebrate

Life

Artful Ways for Special Days

We do not remember days, we remember moments.
—Cesare Pavese

For her father's seventy-fifth birthday, my friend made a special book with the help of her dad's colleagues, his friends, and his family. She asked everyone to think of one word that described her father, Myer, and to share a story or reason why the word fit him so well. She was thrilled when cards, letters, e-mails, and packages poured in from around the world with words like *loving, honest, thoughtful, wise, trusted, generous,* and *kind,* along with stories and images from his lifetime. She and her brother and sister pasted the assembled words and stories into a book she bound and entitled *In a Word.* The first page of the book was a letter from my friend and her two siblings. It read:

Dear Daddy,

We tried to think of the perfect gift for the perfect father, but it was perfectly impossible. There is nothing we could buy that could possibly show you how much we love and appreciate you. Finally, we realized that what you love the most is your family and friends, and we decided to ask all of them to help us create the perfect gift for you.

We asked everyone to describe you in a single word and to tell a story, or just describe why that word reminded them of you. We decided to bind all the stories, so you would have a book of memories from everyone on this special birthday.

What we didn't really expect is what would happen once we started receiving letters, e-mails, and phone calls. The letters were so touching. Some were very funny, and many, many made us cry. After receiving the first few, we all anxiously waited by our computers to see what words and story would arrive next. It became the highlight of our days for many weeks as the e-mails and mail kept coming in.

We know how truly special you are, but it made us even prouder to be your

children when we learned of the new stories, and how you touched so many lives. In the end, we realized this project was an incredible gift for us as well.

We hope you enjoy the letters that came straight from the hearts of all those who love you.

With all our love,
Your children

The following are several examples of the cherished pages.

Beacon

Uncle Myer, I tried to find one word that could easily connect to many. You are . . .

A BEACON OF FAMILY: *providing love, mutual respect, and generosity of time, patience, and commitment to those closest to you.*

A BEACON OF ACCEPTANCE: *being nonjudgmental, open-minded, and respectful.*

A BEACON OF LOVE: *giving your time, energy, and commitment to nurture the best in others.*

A BEACON OF KNOWLEDGE: *sharing easily your life experiences, mistakes, ideas, and dreams.*

A BEACON OF HAPPINESS: *appreciating all that you have, a genuine zeal for life, and recognizing what is most important.*

A BEACON OF SUPPORT: *helping anyone who reaches out or who is too afraid to, holding strong, but not afraid to show how you feel.*

A BEACON OF HOPE: *believing the best in everyone, focusing on the positive, always looking forward.*

Uncle Myer, your beacons have guided me through my adult years.
You have guided me to set my courses in life. Your brightness continues to show me the way.
You are my lighthouse.

Mensch

M—Man of fashion
E—Everyone's pal
N—Noble and Nice
S—Successful
C—Caring
H—Happy and Helpful

Encouraging

Encouraging is the word that I think of when I think of you, Myer. Over the years, you have been a constant source of encouragement for me. You provided me with the ability to find the self-confidence that I lacked. You not only entrusted me to look after your accounting department, but you insisted I put my creative skills to work doing the makeup for one of your advertising campaigns.

Knowing that I had your support led me to grow as an individual, to trust my decisions, to accept changes, and to look at life as an endless opportunity. Contributing to this book is a wonderful way for me to thank you and to tell you that I love you, and that you have played an important part in creating who I am.

Happy birthday!!!

When the book was shared with her father, he was overwhelmed and grateful that he had touched so many lives. He hadn't realized that his actions, kindness, and generosity of spirit had made such a lasting impact.

That's Living Artfully.

Almost a half century ago, a man named Al went to a dance at a hotel. It was love at first sight when he first saw Joanne. They danced the night away; Al asked her to marry him two months later. Joanne and Al had two daughters and were married for thirty-six years before Joanne died of cancer. When Al passed away five years later, his now grown girls found the following poem among his belongings.

Darling Al—

Would I had the words to impart
The thoughts that are within my heart
I would tell you it's been a great life
Since three years ago you made me your wife.
There is so much about you dear,
That grows still dearer year by year.
Your smile, your eyes, your fine strong hands.
You really are a handsome hunk of a man.
But there is the Al that is inside,
That makes me especially glad I'm your bride.
You're kind, and good, and thoughtful, too,
Honest, brave, loyal and true,
Industrious, sweet, lovable,
Strong, gay, dependable,
Musical, articulate, bright,
Generous, conservative, tolerant, and right.
I just love you with all my might!
We have so much to be thankful for,
For Life is full of chance.
But most of all, I thank you dear,
For asking me to dance!
HAPPY ANNIVERSARY!!!!!
July 17, 1963

Joanne and Al's firstborn daughter, Linda, shared this poem with me, along with this thought. She told me that she and her sister were "floored" that their mother had written this poem. "Dad was the poet," she explained. "He used to make us all crazy with his funny little poems for every occasion. Many of them were silly, some even downright bad, but

others were great. You just never knew. We had *no* idea that Mom could write so beautifully; she kept this sentimental talent hidden well." The best part? When the daughter looked at the date, she realized that she would have been conceived close to the date the poem was written. Linda told me, "I will always know the kind of love that brought me into this world."

That's Living Artfully, too.

These examples show the power of celebrations and gifts that come straight from the heart. You never know whom they'll touch or the long-term impact they'll have. The best gifts are not gifts at all, but the people and experiences in our lives.

This chapter shares homemade, heart-made, and handmade artful ideas for creating meaningful moments and for celebrating both special and everyday occasions. Celebrations are an opportunity to use your creativity and imagination to connect with the people you hold most dear. Take the time to celebrate the people and gifts that live in the everyday. It will bring unexpected happiness into your life.

You honor the people you love and cherish when you celebrate them. Celebrate the obvious—birthdays, anniversaries, and weddings. Celebrate for no reason at all. Celebrate anything and everything: your son brushing his teeth without your having to ask; a snow day; a job promotion; the tulips coming up in the garden; yet another Friday; the first day of summer; the last day of fall; a visit from a friend; falling rain; falling in love, or tying the knot. Don't let these moments pass by without truly experiencing and participating in them. Laugh, play, dance, and sing.

Celebrations don't have to require big plans or cost big bucks. The best are often simple and inexpensive ways to say you care. Take a walk with a friend and let her know how thankful you are that she's always there for you; do a happy dance when your daughter cleans her room; celebrate your son getting over his cold by putting mounds of whipped cream on his pancakes in the morning; send a big birthday greeting to a coworker by tape-recording everyone at the office finishing the sentence, "You're the greatest . . . ," or leave a bunch of flowers freshly cut from your garden, wrapped with string and a note that reads "Thank you for being you" on your neighbor's front steps.

Celebrations are an opportunity to use your creativity and imagination to connect with the people you hold most dear.

From the first footprint pressed in a baby's book of memories, we celebrate and chronicle life's events and milestones. Sewing a tooth fairy's pouch, snapping a picture on the opening day of school each year, filling birthday parties with balloons, proudly attending graduation ceremonies, toasting happy couples at wedding receptions, and playing silly games at baby showers fill our life with memories and moments of joy.

Capturing these milestones and creating traditions that celebrate them are common to every country. Across generations and cultures, people gather as they weave ritual, tradition, and family history into life events. These celebrations in part honor an individual, a union, or a rite of passage, but at their very heart, they also pay tribute to something larger than ourselves—our connection to community, to shared life experiences, and to love.

Create new reasons to celebrate. Friends of mine have an "un-party" each year. The purpose of this gathering is to exchange with friends any unwanted, underappreciated, unpleasant, or unexpected gift they have received during the year. This gift swap not only brings renewed belief to the phrase "one man's trash is another man's treasure," it also brings friends together for an evening.

Celebrate a life. One of the best things about birthdays is that we get to celebrate them year after year after year. You can host a party for one hundred or a party for one. Play pin the tail on the donkey or tailgate with a bunch of friends. You can jump up and down, or jump out of a plane and parachute down to the ground. You can sing or be sung to. I know a mom who, on the morning of her children's birthdays, wakes them up with a cupcake on a special "It's your day" plate, and starts their day off with her own version of "Happy Birthday to You." Another gal takes the day off from work, calling it "My Day," spending it at the spa. Her mental and physical health are nurtured as she moves from manicure, pedicure, facial, massage, waxing, and yoga.

Everyone has a birthday, the day you were brought into this world and became a member of the human race. This is the day you became *you*. Your birthday—your

big day—is exciting. Important. Valuable. And it's a time for reflection and good cheer.

Around the world people celebrate this momentous occasion in different, playful ways. For some in Latvia, a naming party is thrown to honor a newborn baby as a full-fledged family member. Guests arrive bearing gifts for the newborn and an abundance of food for the feast. Talk is always happy because it is believed that no unpleasant conversation should spoil the day. The baby's name is announced and songs of good wishes and praise are sung by all in attendance. As the ceremonial dancing begins, the godparents hold the baby and then pass him or her around from guest to guest. It seems in Latvia, everyone gets to hold the baby!

In America we send cards, flowers, and gifts of good wishes to the new mom and her "little bundle of joy." Dads have been known to pass out cigars to their buddies to announce the birth of a son or a daughter. New parents attach bunches of balloons to a fence or mailbox. Blue or pink wooden storks in the front yard carry a sign in their long beaks, announcing "It's a Girl" or "It's a Boy." And of course, we send out written announcements with a photo of the newest arrival.

Prior to the birth of the baby, we host showers to help the new parents prepare for the precious addition to their family. We gather to give the essential things they'll need like diapers and blankets and the tiniest, cutest of soft, cozy clothes. But we also share life lessons, simple truths, and wisdom (both "scientific" and homespun) on raising a child. We play games, laugh out loud, and honor the milestone our female friend is about to reach.

Baby showers can be a lot of fun. There are so many hilarious games to play. One of my favorites is to blow up some *big* balloons, have guests (men included, at a coed shower) put one under their shirt, and then have a race to see who can tie their shoes the fastest! This game is so funny, and the mom-to-be absolutely loves watching her friends bumble and fumble around.

One of the nicest gifts I've seen for a mother and her newborn was lovingly made by a scrapbooker. During a baby shower, she asked all the women to write down on a slip of paper one piece of advice for raising a happy baby. She gathered the inspirational ideas, tucked them into her purse, and later arranged them into a book along with photographs of the

women, the family, and the advice and support of people who love them. When the child was born, she added photographs of the newborn and presented it to the proud parents.

For a bridal shower, create an advice book for a young bride-to-be. Fill it with poems and verses to give her a map as she makes her way through this new territory. The advice can be clever or simple, like: "Take each other for better or for worse, but never for granted," and "The secret to a long marriage is to put a little romance in every day." The suggestions reflect experience, faith, and a healthy dose of optimism.

To celebrate a new life, a woman asked me to create a journal so that she could gift it to a surrogate mother who was about to carry her child. I titled the book *Embrace Life*. Over the months that the surrogate mother carried the baby, she made an entry each day (adding images of the sonograms and pictures of her growing belly), all the while writing her thoughts and feelings as she nurtured this precious gift. The surrogate delivered a healthy baby boy, and also included her reflections and memories of the growing life inside her.

That's an artful gift of life.

For my husband's birthday, I invited our friends to our home for a birthday party. I asked that they bring only one thing as a gift—a wish for my husband. As the guests arrived, they each gave me their wish. Some were sealed in envelopes, one was written on a napkin, and another was scripted on a piece of blue paper folded beautifully to look like a bird. I placed all the wishes in a simple velvet bag and after Mark blew out the candles on his cake, I gave him the bag of wishes. He read them all out loud, and he loved all of them. Some were funny. Some were kind. Some risqué. But all were a wish and a hope for another year of a good life. I hadn't anticipated how meaningful the gift of the wishes would be for him. He still talks about it being the best gift he has ever received.

Write goal lists or "birthday wish lists" on your special day. You've heard of the practice of writing down your goals on New Year's Eve, or on New Year's Day. That's nothing new. But on a birthday? This is not just

about honoring and celebrating your very own special day, but about honoring and marking the shift into your own personal new year (literally). Some astrologers say that on your birthday, the Sun—the planet of health and career—is in the exact place in the sky as it was on the day you were born. Some take that to mean that anything you put in place on that day (anything that you wish for) will have more focus and power than usual because of this planetary alignment. I don't know if that's true or not, but it sounds like a fun way to think of your birthday. In case there is some truth to this, why not harness the power of the day you were born to help kick-start your personal new year with a bang? Sit down. Light a candle. Put on your favorite music and write away. Anything goes—this is a wish list, after all. Do you want to go to China? Surf the coast of Maui? Write a novel? Open a bakery? Meet your soul mate? Who knows . . . you may just be crafting the blueprints of a glorious future!

For her dad's seventieth birthday, a woman penned "The seventy things I love about my dad" on strips of colored paper and presented them in a beautiful box.

I love . . .
your smile.
the way you laugh at nothing at all.
the way you held my hand when you walked me to school.
your spaghetti with meatballs.
you.

You, too, can create a "Because Box"—a beautiful little box filled with notes to complete the phrase "I love you because . . ." Make one for birthdays, anniversaries, weddings, graduations, or just because. I promise this token of affection, created in your own unique style, will be a cherished treasure to anyone who receives it. Simply jot down thoughts that finish this sentence: I love you because . . .

your belief in me has helped me grow.
you are funny.
you listen to me.
I know I can trust you.
you make me laugh.
you bake the best cookies.
I love watching you with our children.

Make a movie on your computer about the birthday girl or boy. Gather photographs from his or her life and add favorite songs. As one image fades out and another fades in, a lifetime will be revealed. Put it on a DVD and show it on your big-screen TV. People of all ages will love and treasure it.

When my Granny turned ninety-eight years old, her memory was sometimes spotty. She started asking us, "How old am I?" and we'd all loudly reply, "Ninety-eight" (her hearing wasn't what it once was). As we planned her party, my sisters and I thought long and hard about what could be the perfect gift (as Granny says, "At ninety-eight, what more could a person want or need?"). But we wanted her to know how much she was loved, and also, we wished we could help with her failing memory. So we decided to ask as many people as we could to write a letter telling Granny how much they loved the hand-knit granny slippers she had made for them. We called tons of folks and each returned to us a letter that we placed in a book. On the cover of the book we glued an actual granny slipper.

Granny loved the book and loved reading letters like these:

Dear Granny,

If you have ever been fortunate enough to receive a pair of Granny's slippers, you are a very lucky person. I have, and I know. Through the years they have become something that I would have a difficult time being without. In the evening—summer or winter—they feel so good to slip into. A rainy day, when you don't have to go out . . . put on Granny's slippers. If it is a trip . . . they have been around the world with me. Have to go to the hospital? Granny's slippers go along to keep the tootsies warm and to comfort you. As you put them on, you know that each slipper was really made for you, with love, by Granny. How very, very special are Granny's slippers and Granny!

Another read:

Dear Granny,

Sandra gave me a pair of your hand-knit slippers as a gift over two years ago, right before I was due to give birth to my first son, Jack. I still remember packing them up in my bag that I was taking to the hospital, hoping that they would comfort me while I was away from home. I wore them every day when I was there, and when we had complications and I had to go down to the intensive care unit in the middle of the night, I would wear my "granny slippers," sit in the rocking chair, and hold my precious baby for hours. I remember feeling warm and cozy in my slippers, and feeling like I had a special guardian angel watching over us during these difficult days.

In a week I will be going back to the hospital to give birth to our second child. My bags are packed and my slippers are safely tucked inside.

I don't think I can truly express in words how many great memories I have of the things I have done while wearing your slippers. They have brought me a constant source of warmth and love. I thank you with all my heart for your incredibly special and heartfelt gift.

Granny loves the book and shares it with anyone who comes to visit. She often looks at it and reads the letters. They make her happy, reminding her of the special people from her long life. Thankfully, her hearing loss does not detract from the power of the words written on the pages.

Our second gift to Granny was actually a party favor for each guest to wear at the celebration—a picture of Granny centered on a paper tag with a ribbon through a hole to create a necklace. Above her photo we wrote in large type "How old am I?" Underneath her image, we placed a big "98." Each time she asked, "How old am I?" we silently answered by pointing to the necklace (worn on all of our necks). Granny laughed and said, "That's old!" We agreed! We were so thankful to celebrate another year with her.

Birthdays are a wonderful excuse to gather together friends and family for a party. Don't miss the opportunity to celebrate the birth of an individual and the birth of a memory.

Celebrate the firsts, the lasts, and everything in between. Every September, sure as clockwork, summer comes to an end when the first morning of school arrives. Lazy days, swimming pools, flip-flops, and vacations are exchanged for alarm clocks, book bags, school buses, and schedules. In my house, we have a love/hate relationship with the beginning of school. We hate to see summer come to a close, but we love to start a new year, filled with possibilities and friendships.

The moment our daughter started school, we started a tradition. Dressed in her finest first-day outfit, Hannah is photographed with book bag and gear. She is now in eleventh grade and we have twelve priceless photos (starting with kindergarten) of our baby as she has grown into a young woman. I wish I could say that I started organizing these memories into a photo album twelve years ago, but I did not. Until recently, the images were scattered among hundreds (honestly, thousands) of pictures that I, like many others, kept in shoeboxes. When I started searching to recover all twelve photographs, I was grateful to discover that some had magically appeared in frames while others rested patiently in their boxes. Excavating them was a wonderful journey through our life, and I was reminded of the people and events that have made it so special. Each of Hannah's

pictures reflected a step in her life. The other photographs showed me the road we'd all taken together.

Documenting life's milestones and passages through photographs, and assembling them in albums or scrapbooking them creates a treasure that has lasting meaning. We send a message to our children that they matter, that their experiences are important, and that we love them. We teach them to cherish the people and moments in their lives when we cherish them in theirs.

I am happy to say that after all these years, I have finally gathered all the photographs from the first day of school, and will continue our tradition until she graduates from college, beauty school, or medical school. Together we are creating an artful book of memories to share and enjoy forever.

When we craft albums and scrapbooks, we are participating in a quiet revolution, a reawakening to what is truly important by celebrating the people and moments that make life wonderful. Scrapbooking helps us to express our creativity, nurture relationships, document special moments, have fun, and build traditions. It enriches our lives. Scrapbooking is another way to communicate. It's a language of the heart.

Celebrate love. Around the world, people celebrate the union of two hearts in many beautiful, artful ways. In San Francisco, as couples of the same sex were being married in the city hall, flowers anonymously sent from all over the world filled the offices with heartfelt best wishes, sharing the message that love is all you need.

At wedding ceremonies in Armenia, often two white doves are released as a symbol of love and happiness. In Bermuda, many islanders top the wedding cake with a tiny tree sapling. The newlyweds plant the tree in the yard of their home following the celebration and together they care, tend, and watch it grow along with their union.

Traditions abound around the wedding ceremony. The tradition of "something old, something new, something borrowed, something blue" dates from Victorian times. "Something old" symbolizes the bride's past and the connection she will always have to that past. A bride may choose a piece of old jewelry from her grandmother to wear during the

ceremony. "Something new" represents a wish for success, happiness, and good fortune in her new life. "Something borrowed" reminds the bride that her friends and family will always be there for her. "Something blue" represents faithfulness, fidelity, and loyalty. The color blue has represented purity and constancy since biblical times and brides often wear a blue garter or borrow a handkerchief with blue lace to continue this tradition.

At the wedding ceremony, the judge, rabbi, or pastor may ask, "Who gives this hand in marriage?" and the father (and sometimes the mother, too) says, "I do." This tradition of asking for the bride's hand in marriage finds its origin in a Roman custom called the "joining of hands." In a symbolic gesture, the groom gives a coin to the bride's father and she in turn is passed from the father's "hand" to his.

Most families have time-honored ways in which they celebrate love and marriage. Share them, pass them on, and celebrate as you exchange your vows and rings, dance your first dance, cut the wedding cake, save a piece of cake, break the glass, plant a tree, stand under the chuppah, throw the garter and the flowers and the rice, give almonds coated with sugar, and before all promise to love, honor and cherish one another.

n the news recently, I saw a wonderful piece on a cornfield somewhere in the Midwest. The corn was trampled in places to create the question "Will you mary me?" in big, capital letters. Apparently the young man who created the "corny question" took his girlfriend up in a plane and as they were directly overhead, he asked her to look out the window. She said she would marry him, but pointed out that he had misspelled the word *marry*. He explained that he knew about the error, but he had no choice, as he was running out of field in which to write "I love you."

The tradition of a young man kneeling to ask a young lady to be his wife finds its origin in the days of knighthood and chivalry. It was customary for a knight to dip his knee in a show of loyalty and servitude to his lord and lady. In kneeling down before a tournament, "his" lady would toss him her ribbon as a symbol of her favor of him.

A couple was joyfully reunited after a long time apart. They'd broken up years before

Celebrations don't have to require big plans or cost big bucks.

when the man had felt ready to marry, but the woman thought herself too young and imma-ture and had refused his proposal. Their lives had taken many twists and turns since, but now it seemed that fate was smiling upon them and giving them a second chance. The woman had matured and grown, and realized all she had lost in leaving her true love. She was determined not to make the same mistake twice. But one day, after six happy months back together, he informed her that he would never propose again. She knew in her heart that they were meant to be together, so instead of being hurt or discouraged, she decided to take matters into her own hands. She would be the one to propose this time around.

The woman arranged for the big moment to occur at a Chinese restaurant while they were on holiday in New York City. She slyly slipped the hostess a small package upon arriving, and when dinner was complete and the dishes were cleared away, the waitress brought them their check with two fortune cookies. The woman waited excitedly as the man casually opened his cookie and read his fortune. "Will you marry me, Sweet William?" On cue, the couple's favorite song came blasting over the sound system. The man looked around amazed, only to notice the hostess beaming from her station, the waitress weeping through the fish tank, the busboys peeking from around the kitchen door, and tears streaming down his sweetheart's face. He said yes, they were married, and they continue living happily ever after.

Tell the person you love how much you care. A young couple was about to have their eighth wedding anniversary. The husband was away on business, so they couldn't celebrate their big day together. The wife wanted to get him a card and a special gift to show her love, but wasn't sure what to get him and didn't have much money. She went to a nearby drug-store and took several minutes reading the many amusing, sappy, and romantic anniver-sary cards. She chose a humorous one and turned to pay the cashier when she noticed the large candy aisle. Her husband loved candy, so she thought she'd get him something sweet to send with the card as a little goody on top of whatever gift she figured out.

As she approached the many sweet selections, she noticed a Big Hunk bar and chuck-led to herself that her "big hunk" of a husband might appreciate a candy bar that also took the form of a compliment. A Mr. Goodbar chocolate bar caught her eye next, and soon

every candy she saw made her think of how she felt about her husband and how special she thought he was. She quickly collected eight packaged candies—one for each year of their marriage, and sent them wrapped in tissue and tied with a bow. She included the card inscribed to say, "To my mister, the contents of this package remind me of you. Enjoy a treat for each sweet year of our life together." Inside he found the goodies, as well as an M&M's M-Azing bar, a S'mores bar, a 100 Grand bar, a package of Now and Laters, a Sugar Daddy, and a box of Good & Plenty.

If it's true that the way to a man's heart is through his stomach, then for just $13.65 this wife found a clever way straight to her husband's heart.

Life is a song, so sing along. A bride-to-be wanted to have a very special compilation of music to be played at her upcoming wedding reception. She and a girlfriend went to a music store that had a high-tech computer system that would enable them to look up any recording of any song she wanted. She'd planned to order numerous songs that she and her fiancé had enjoyed in the years they'd dated—songs that meant something special to them as a couple. Since her betrothed's name was Bill, she wanted the first song played to be "Wedding Bell Blues" by the Fifth Dimension (that has the lyric "Bill, I love you so, I always will . . . won't you marry me, Bill?"). Her name was Carol, and on a whim she thought that after that song, it would be funny to play Neil Sedaka's hit "Carol" with the lyric "Oh Carol, I'm in love with you." She then got to thinking, perhaps there were other songs with the name Carol and Bill, or William, in them. She turned to the amazing computer program and it informed her that there were 1,388 songs with the name Carol in the lyrics, 1,559 with the name Bill, and 357 with the name William. Her friend was intrigued to find that even her much less common name, Megan, was featured in thirty-eight songs! Surely most everyone had a song written seemingly just for them! Carol went a step further, scanning the lists of songs to see by whom they were performed and when. She was thrilled to find that many of them were fairly contemporary, and most of them were love songs or songs of celebration regarding someone with the names of herself and her beloved.

The groom and guests at their wedding reception were amazed at the mix of songs that were *especially* personal to the happy couple.

In Tokyo at the Meiji Shrine, there is a kiosk with wooden plaques hung on simple red threads. Visitors are invited to write their hopes and wishes for the couples who are married there. These "ema", or prayer boards, are a beautiful way to celebrate love.

One day a written request arrived in our mailbox. It read:

Dear Friend,

On December 26 Nancy and Richard will be celebrating their 40th wedding anniversary.

I know you'll agree this remarkable occasion deserves a special remembrance, and to celebrate their love and friendship, it will be fun to present them with a truly unique gift—an album filled with pictures and other loving memories of their wonderful life over these years—a "Remember When" album.

I am writing to ask you to be a part of this special album. Whether you've known each other for many years or just a short time, I know you're aware of the high value placed on your friendship and times together, and you know how much your shared memories will be appreciated.

If you have a photograph of yourself or a photograph reminiscent of your time together, please attach it. Although a picture isn't necessary, I'm sure they'd love to see it if you have one. Then, use the remainder of the page to jot down your remembrance and to talk about the wonderful things you did together. The pages will be gathered into a beautifully bound album, with each page a unique reminder to them of the very special remembrances and times you've shared.

As you might imagine, Richard and Nancy love the album, and are grateful to their friends for the efforts they made to make it. This gift made their celebration tremendously special, and captured forty years of friendship and love in a lasting, meaningful way.

Give a gift from the heart. The best gifts are not found in a store, are not expensive, and are not always tied up with a bow. The best gifts are found in your heart.

So often when we think about "what" we can give someone, we think of a thing, an object—a big something. But when it's time to give a gift, try thinking about sharing something that is not a thing: a kind word, a thumb's up, a few minutes to really listen, or a heartfelt compliment.

Tell someone that he or she did a nice job, that her hair looks nice, that his flower garden makes you smile, that you appreciate all they do for you. These are gifts that resonate and will not soon be forgotten.

Our gifts are messages from the heart. While I was on the train the other day, I happened to overhear two men dressed in business suits. One said, "My mom gave me a fortieth birthday present last night. Unbeknownst to me, she had saved all of my artwork I made as a kid. She framed one of my paintings, and gave it to me to celebrate my birthday." The other man said, "Wow, really?" The first man replied, "Yes, I loved art in school, and for so many years I haven't had the time to do it. My mom recognized that, and wanted to remind me how important it was to me."

Isn't that amazing? What a great gift—a piece of art, plus a reminder to do what you love. So many parents keep old school reports, art, or class projects in a file, a trunk, or in the garage. These treasured "relics" might be just the right gift at the right time. In short, you may already have the best gift you can give.

In my own family, when we five sisters turned "sweet sixteen," each of us received a small diamond necklace from our parents. The necklaces were fashioned from little diamond chips that were in our late grandfather's ring. We each were given one as a token of love and celebration from our parents, and as a reminder that as we grow and become independent, we will always be a part of and loved by our family. When my daughter turned sixteen, my husband and I gave her my necklace so that the tradition and message pass on.

When you give a gift that has special meaning, it will always be remembered and treasured. When her son and daughter-in-law were expecting their first child, a woman I know gave the first books she read to her son as a baby shower present. She had saved

Celebrations in individual, a rite of passage, very heart, tribute to than ourselves— to community, experiences, and

part honor an
union, or a
but at their
they also pay
something larger
our connection
to shared life
to love.

them throughout the years in the attic and knew just where they were when it was time to pass them along. Her son had loved the stories his mother had read to him, and looked forward to reading them to his child.

A friend went on vacation with her whole family. With her parents, siblings, their spouses and families, they rented a big house at the beach. They enjoyed the time together, took long walks, cooked huge spaghetti dinners, sat on the beach until the sunset, and had cocktails in the sand. Everyone said it was great to be with the whole clan. They caught up, shared some wonderful memories, and created new ones. Deciding to commemorate the glorious family reunion, my friend created little shadow boxes filled with the treasures she found on the beach: shells, sea glass, sparkling sand, small pieces of driftwood. She added photographs and a little plaque that read "Smith Family Reunion, Summer of 2005," and sent one to her siblings and her parents. Next year she plans on having the family create new memories along with more memory boxes at the beach, together.

Twice a week the patients of the Jacob Perlow Hospice Inpatient Unit at New York's Beth Israel Medical Center, along with their families, are given dinner courtesy of five of New York City's finest restaurants. "These special meals are an opportunity for patients and their families to feel the love and support of the community," explains John Chermack, director of special projects for the hospice. The general manager, Mark Maynard-Parisi, of Blue Smoke (one of the participating restaurants), came up with the idea while visiting a friend at the hospice. This gift of food is a culinary kindness. "For the patients and their families, it's an opportunity to have something enjoyable when life isn't very enjoyable for them," says Maynard-Parisi.

I know a woman who never travels away from home on business without leaving behind funny, touching reminders for her husband and children that she's thinking of them. Throughout the house she hides little notes and small gifts (like homemade CD compilations of their favorite songs and small toys or candies) and then gives them hints each morning when she calls to wish them a happy day. Each day is a mini treasure hunt in her absence, and by the time it's time to pick her up at the airport, her family is so full

of love for her that they come to her terminal bearing their own gifts (and flowers)! Give and you shall receive.

Celebrate you. Of all the many things and occasions there are to celebrate, the most often overlooked and rarely celebrated is your self. By celebrating yourself, you are valuing and nurturing the unique gifts that make you special. Ask yourself what matters and what is meaningful in your life. What moments do you treasure? Which people do you cherish? Who do you want to be? How can you make the world better? The meaning of life is found in the moments we live every day: a kiss on the forehead, the gentle touch of a child when he or she holds your hand, the familiar smile of a loved one. These moments are there for us, if we just choose to recognize them and act on them. There is real meaning in the care of a friend, a wave to a neighbor, and compassion for a stranger.

Thousands of years ago Socrates recognized that "the unexamined life is not worth living." The inscription on the temple at Delphi, where the Greeks sought to learn their future, is simple, yet profound: "Know thyself." And Shakespeare's *Hamlet* carries this timeless message: "To thine own self be true."

These ideas are as important and valid today as they were many years ago. Care for yourself and take time to define what is important and meaningful in your life. Then, discover and celebrate your own unique way to say what you believe. It doesn't matter whether you sing in the choir, bake cookies for a neighbor, volunteer at the local blood drive, or babysit a friend's children. Each act expresses something essential, and illuminates and celebrates those things that give life meaning.

Artful Ideas for Everyday with FRIENDS

- Host a dinner where everyone brings the ingredients to make a dish. You'll fill the kitchen with activity, talk, and fun as you all work together to create a fabulous meal.

- Pull out the fondue pot and heat up different cheeses for a night of dipping fun. Cube the best-tasting breads you can find—I like plain sourdough, garlic-rosemary, and olive bread. For dessert, melt chocolate and dip strawberries, bananas, and graham crackers into the heavenly mixture.

- Invite friends and family for a bulb-planting party in the fall, and then in the spring, invite them back to see the beauty they planted.

- Build a campfire in the backyard (in the grill or a fire pit) and roast hot dogs on sticks and make s'mores with chocolate bars, marshmallows, and graham crackers. Sit around and tell stories and enjoy the flames as they warm your fingers and toes.

- Go miniature golfing together. Set up teams and prepare to laugh as children and adults alike compete for the lowest score. Give prizes to the winners, both old and young.

- Get tickets for your local professional, minor league, or college baseball game. Spend an afternoon in the sun with chocolate malts and peanuts, and singing during the seventh-inning stretch. (If you get there early, you may be able to catch fly balls from batting practice.) Consider tailgating, and create and serve a feast from the trunk of your car.

- Go ice-skating, or to a roller rink, and dance to the music booming over the loudspeakers.

- Check out the local public gardens in your area, perhaps a tea garden or one with acres of roses.

celebrations and Family

- Visit your local live theater and support your neighborhood thespians as they perform in *A Midsummer Night's Dream* or *Annie Get Your Gun*.
- Has the fair come to town? Carnivals and fairgrounds are a good way to change your routine and celebrate your country roots.
- Bring out all of the board games you can find. Enjoy some healthy competition as you play. Fill bowls with popcorn, chips, nuts, and chocolate for the competitors.
- I love a good game of Blackout: turn out every light in the house (that includes nightlights and VCR lights) and play hide-and-seek. Prepare to have a blast tripping all over each other and even getting spooked a time or two.
- Sing at home in karaoke style. Crank up the tunes and laugh as everyone takes a turn singing his or her favorite song.

FOR ANNIVERSARIES

> Love does not consist of gazing at each other, but in looking together in the same direction.
> —Antoine de Saint-Exupéry

- Create an "I Remember" book filled with memories of a life lived with love.
- Leave a little note under the pillow on the morning of your anniversary that simply says "I love you."

- Using an old wine bottle, create a time capsule to be opened on some future wedding anniversary.
- Create a simple, elegant handmade card by cutting a heart out of paper you like (a piece of wrapping paper, newspaper, tissue, or floral wallpaper) and gluing it to a blank card. Fill the inside of the card with quotes on love. Here are few of my favorites:

> Our wedding was many years ago. The celebration continues to this day.
> —*Gene Perret*

> Love is the thing that enables a woman to sing while she mops up the floor after her husband has walked across it in his barn boots.
> —*A Hoosier farmer*

> It's so great to find that one special person you want to annoy for the rest of your life.
> —*Rita Rudner*

> A successful marriage requires falling in love many times, always with the same person.
> —*Mignon McLaughlin*

> There is no more lovely, friendly, and charming relationship, communion, or company, than a good marriage.
> —*Martin Luther King, Jr.*

- Tape a note on the bottom of your loved one's glass of milk or juice. Watch as he or she finds the treasure at the bottom of the glass.
- Wrap a candy bar in a note that says "You're my sweetheart," or "You're the sweetest thing in my life," or "Have a sweet day."
- Plaster his or her car windows (front and back) with huge anniversary cards or leave a little note on the steering wheel that reads "I love you with all of my heart."

- Have a romantic CD waiting on the dash of your partner's car, with a note asking him or her to listen.
- If it's a "big" anniversary, after dinner, get out the CD player, play "Two Tickets to Paradise" by Eddie Money, and give your beloved two tickets to a cruise. (Of course, he or she must bring *you*!)
- Start the day off with a little love by making heart-shaped pancakes for breakfast.
- Surprise him or her at the office with a special lunch brought in for two.

FOR BIRTHDAYS

> Birthdays are good for you. Statistics show that the people who have the most live the longest.
>
> —Larry Lorenzoni

- On your loved one's birthday, send his or her parents a thank-you card.
- Each year on your child's birthday, write a letter sharing details that recap his or her year, and how much and why you love your child. Store them in a box to present when the child heads off to college.
- For a fiftieth birthday party, request that all gifts have something to do with the number fifty: fifty golf balls, fifty little pieces of chocolate, fifty notes to open for fifty days, a fifty-year-old book.
- Make an artful label for a wine bottle. Take a picture of the birthday girl or boy and glue it to the bottle over the old label. You'll create a whole new vintage. Wine not?
- Wrap bottles of bubbles with wishes for the birthday girl—the inscription might read "Thank you for blowing into our life."
- Make posters wishing someone a happy birthday and hang them on trees and lampposts leading the person home from work.

- Play pin the tail on the donkey at a child's party. For a grown-up party, blow up a picture of the birthday girl or boy and pin the tail on his or her picture. This game will bring lots of laughs, I promise.
- Before you blow up clear or light-colored balloons, write a birthday wish on a star-shaped slip of paper and put it inside the balloon. Have the balloons filled with helium (at your local party store) or blow them up yourself.
- Slumber parties aren't just for kids. Invite your girlfriends to come over (and bring pajamas) for a night of princess delights. Arrange to have a massage therapist, psychic, or tarot card reader, and a manicurist. Indulge, have fun, laugh, tell secrets, and play with your friends. Have a breakfast of Belgian waffles, whipped cream, and strawberries.
- Create a birthday card. Glue a photo of the birthday gal or guy on the front and write a great quote inside. Here are some fun suggestions:

> And in the end, it's not the years in your life that count. It's the life in your years.
> —*Abraham Lincoln*

> A diplomat is a man who always remembers a woman's birthday but never remembers her age.
> —*Robert Lee Frost*

> The secret of staying young is to live honestly, eat slowly, and lie about your age.
> —*Lucille Ball*

> With mirth and laughter let old wrinkles come.
> —*William Shakespeare*

> One to-day is worth two to-morrows.
> —*Benjamin Franklin*

> No wise man ever wished to be younger.
> —*Jonathan Swift*

> Grow old along with me! The best is yet to be, the last of life, for which the first was made.
> —*Robert Browning*

Old age isn't so bad when you consider the alternative.

—*Maurice Chevalier*

Age is not important unless you are a cheese. —*Helen Hayes*

All the world is birthday cake, so take a piece, but not too much.

—*George Harrison*

FOR A NEW BABY

Babies are such a nice way to start people.

—Don Herrold

- Create an advice book for raising a new baby. Ask friends and family to jot down a piece of wisdom—good advice for raising a healthy, happy child. Paste them into a book with a pretty cover.
- Plant a flowering tree when a child is born. A cherry, an apple, a dogwood, or a magnolia are perfect trees to plant. Watch as it and the child grow and blossom.
- At a baby shower, serve all food in miniaturized or "babyized" versions and all the drinks in baby bottles. Petit fours, canapés, and mini crustless sandwiches are several ideas.
- Baby showers are such a fun way to welcome the little one into the world. Play games: have a few baby bottles filled with something ready to drink. Start a timer; the person who is done drinking first is the winner. Dads-to-be love this game and the mother-to-be will get a kick (ha-ha) out of it, too.
- Give out minipacifier necklaces, with instructions to try and trick the other attendees into turning over their necklaces by getting them to say the word baby. Watch as

creative partygoers engage each other in seemingly harmless conversation like, "Do you have any children?" and "What year was your first child born?" You'll be amazed at how this always leads to women absentmindedly uttering the word baby, and how one or two partygoers will end up with fifteen pacifiers around their necks.

- At the shower, have your guests each bring a baby picture of him- or herself. Pass around the photos and see which guests can match the person at the shower with the baby picture. Whoever gets the most right is the winner.

FOR A WEDDING

> Love one another and you will be happy. It's as simple and as difficult as that. —Michael Leunig

- If you're the one getting married, surprise your spouse by having a garland of sweet-smelling flowers placed across the top of your bed's headboard for your first night home from the honeymoon.
- Create a wisdom treasury with wonderful quotes from famous folks. Research (on the Web, in the bookstore, at the library) celebrities whom the bride and groom like, and see what they have to say on the topic of love and marriage. A few include . . .

> Never go to bed mad. Stay up and fight. —*Phyllis Diller*

> Nobody has ever measured, even poets, how much a heart can hold. —*Zelda Fitzgerald*

> There will be sex after death, we just won't be able to feel it. —*Lily Tomlin*

Being deeply loved by someone gives you strength, while loving someone deeply gives you courage. —Lao-tzu

Anything worth doing is worth doing slowly. —Mae West

Sexiness wears thin after a while and beauty fades, but to be married to a man who makes you laugh every day, ah, now that's a real treat. —Joanne Woodward

Write a toast for the newlyweds or memorize an old standard.

May you always have warmth in your igloo, oil in your lamp, and peace in your heart. —An Eskimo toast

May you never forget what is worth remembering, or remember what is best forgotten.

May your children be blessed with rich parents.

It don't matter where you get your appetite, as long as you eat at home!

May the best day of your past be the worst day of your future.

May "for better or worse" be far better than worse.

—Irish blessings

- Create a scrapbook of the bride and groom, with photos of each starting in childhood. Leave the rest blank so they can add to the book together from here on.
- For a bridal shower, purchase rolls of white toilet paper. At the party, divide the

guests into two or more groups of three to five people. Each group must design and fashion a "wedding dress" out of toilet paper and choose someone to model it (mother of the bride and father of the groom are usually good choices) as they're constructing it. Accessories are allowed (earrings, bouquets, trains, headpieces, wedding ring, etc.) but they must all be fashioned out of toilet paper. Once the groups are finished, the bride picks the winning dress and the team members all get a prize. Take pictures!

Remember,

There is only one happiness in life, to love and be loved.
—George Sand

The best thing
to spend
on your friends
and family
is time.

happy holidays

New Ways for the Big Days

> Blessed is the season which engages the whole world in a conspiracy of love. —Hamilton Wright Mabie

When I was a little girl, on Christmas mornings, whichever sister woke up first would wake up all the other sisters. We then lined up at our parents' bedside to wake them up so we could all see if Santa had come. My father would rub his eyes, pull his legs out of bed, and put his feet on the cold floor to begin his journey downstairs to check. My mother wrapped her robe around herself, asking, "I wonder if Santa came?" My sisters and I were firm believers in Santa. When my father *finally* hollered from the living room, "Okay, you can come down now," we all ran down the stairs, thrilled to see the lights twinkling on the tree (of course, years later, we learned that my father needed the few minutes to plug in the lights and finish last-minute details), and the mounds of brightly colored packages. We would each pause for a second to take in the magic of the moment.

Then, utter chaos began as my sisters and I searched frantically to find our pile of gifts. Once we found them, we tore through the paper and into the boxes. Sometimes two of us reached for the same box and pulled like it was a tug-of-war game, until we saw a tag bearing one of our names. We dug through and uncovered gift after gift. We were giddy, almost to the point of intoxication, by this frantic dance. Occasionally, the tearing of the paper was punctuated by a voice: "Mom, look! A new doll!" or, "I love this!" The blur of activity continued until we collapsed into our bundles of new socks and underwear, puzzles and dolls, games and chocolate candies. It was over. We were delighted! Our mother and father were exhausted, and we still hadn't had breakfast.

Christmas mornings unfolded this way for many years in our childhood home. As we grew up, my sisters and I began to see and recognize my mother's great efforts and fatigue as she shopped for five girls, prepared the Christmas dinner, baked all the cookies, wrapped all the gifts, and hosted family and friends with flair. She performed all these "extras" during the holiday while still managing and cleaning the house, carpooling, and

166

taking care of her family. I look back on those days and on my mother with gratitude and awe. I honestly don't know how she did it. Her efforts only enhanced my belief in the magic of the season and in the power of multitasking.

Looking back, I see that my mom was trying to create the perfect holiday. She, like so many women, believed that everything had to be perfect, that she had to do it from scratch, and by herself. Although this attitude often makes for a holiday to remember (by your family and friends), the gal orchestrating all of this is often left exhausted and resentful. Basically, she has no fun at all.

Too often, our holiday celebrations are filled with such tremendous effort, chaos, and stress that they cease to be happy. In all the rush, we misplace the value of simply coming together with family and friends. We overspend, overindulge, and overlook the reason we have gathered. In this chapter, I will share some simple, meaningful, and artful approaches to embracing the true spirit of the holidays.

The yearly calendar is punctuated with holidays that most families acknowledge and celebrate, including New Year's, Easter, Mother's Day, Father's Day, Halloween, Thanks-giving, Hanukkah, and Christmas. For many of these holidays, we take time off from work, prepare food, decorate the house, give gifts, and gather with our friends and family. Some people have established traditions and rituals around these holidays, others simply wing it each year, making up new and spontaneous approaches to celebrate the occasion.

Some celebrations are low-key, relaxed events. Others are akin to a three-ring circus with more cooks in the kitchen than can comfortably fit. Some are quiet and reflective to honor the occasion, while others are loud, boisterous, and filled with dance.

There is no right or wrong way to bring in the new year, tell your sweetheart you love him or her, welcome spring, honor your mom, celebrate the birth of our country, give thanks, or make the season merry. However, there are ways to take the stress out and to add more meaning, relaxation, joy, and happiness to these events. In these pages, you will find many ideas and inspirational stories of the diverse, unique, creative, playful, artful, and meaningful ways people honor holidays. Allow them to inspire, rekindle, spark, and enhance the ways you celebrate in your home.

Too often, our holiday celebrations are filled with such tremendous effort, chaos, and stress that they cease to be happy.

Start the new year with a new take on life. Make a list of the things you most wish to accomplish, see, or do this year. Not just the big things, but most important, the little things you want to do more of. Things like:

Find and call my best friend from college.
Tour a vineyard in Italy.
Take a class on Indian cooking.
Read more books.
Take a nap on Sunday afternoons.
Pick more bouquets of flowers.
Plant a few more varieties of tomatoes in the
 garden this summer.
Laugh more and laugh often.

Write down your thoughts and put them in a place where you can see them throughout the year. Hang them on the fridge with a magnet. Frame them and put them on your desk, put them in your wallet, or hang on a mirror in the bathroom—somewhere, *anywhere* that you will see them and act on them! Your year will be filled with new experiences, new friends, new ideas, and new beginnings.

New Years. All over the world, the new year is thought to be a time to invite good luck into your life. In Puerto Rico, families throw pails of water out the window to rid the home of "evil" spirits and encourage good luck to visit. In Spain, when the clock strikes twelve, folks eat twelve grapes—one for each stroke of the clock, and to represent the twelve months to come, filled with good luck. And in Armenia, women bake bread, kneading it with wishes of good luck for the new year. Creating a tradition that invites good luck into your home can be as simple as penning a poem honoring the new year. Raise a glass with sparkling cider or champagne and say, "May your new year be filled with good cheer and good luck be had throughout the year."

Host a party to ring in the new year. Buy some inexpensive champagne flutes, one for everyone. Ask your guests when they arrive to write their resolutions on a champagne flute with a permanent gold marker (bought at stationery or craft stores). Have a table filled with small round ornaments, tinsel, and brightly colored ribbons. Invite them to decorate the stem of their flute with their own personal style (some folks might also decorate themselves!). All night long, your guests will recognize their glass (and other guests) by their artful creations. Their resolutions will make for fun conversation and serve as a delightful and easy icebreaker. Invite your guests to take home the glass, along with memories of a fun-filled new year.

I know a couple that does the same thing every New Year's Eve. They dress up in their finest black-tie clothing. She polishes her nails, he polishes his shoes, and they meet in their dinning room at 8:30 p.m. for a romantic dinner for two. They decided long ago that the noise of parties, the rush of traffic, and the hustle and bustle of the night was not for them. Instead, they turn on their favorite music, share a bottle of wine, enjoy a delicious dinner (they prepare together), and sometimes they even dance. They start off the new year connected and together.

Although New Year's is a time to look forward to the coming year, it is also a time to look back at what has happened, what mattered, and what and who is important in your life. Take a few minutes or a few hours on December 31 to reflect on the year that is passing, to pause, to give thanks, to honor a time that has come and gone, and to remember. Look at your old calendar and recall the days and events that have passed, recounting what you have accomplished, remembering the people, reflecting on the fun you've had, and the work you've accomplished. Replay the treasured sequence of events that can be so easily forgotten.

Valentine's Day is often promoted as the best day of the year to express romantic love. But I recently heard about a perfectly sweet way to remind friends that they are special and loved, too: have a chocolate party. Invite friends to come over for a fun-filled evening of chocolate making. Gather ingredients to make fudge, toffee, and truffles—

along with toppings like pecans, peanuts, sprinkles, chocolate chips, marshmallows, and raisins. Share chocolate recipes and tips. Before the evening comes to a close, fill Chinese take-out boxes with the chocolates, so that everyone goes home with sweet treats to eat and to share (if any chocolate makes it home).

My friend's uncle recently passed away. Knowing that her aunt would be missing him as Valentine's Day approached, she and her kids made a special card. They pasted a picture of themselves on the front (cut in the shape of a heart) and the kids wrote, "We love you sooooooo much, Aunt Suzanne." They filled the envelope with heart confetti, and when she opened the note, her world (the floor, her lap, the desk—everywhere) was filled with love.

Don't reserve Valentine's Day for romantic, passionate love only. Make it a day to say I love you to all the people in your life, including yourself. Place a heart-shaped chocolate on a coworker's desk; send your child to school with a bag of handmade Valentines for friends and teachers; leave a Valentine in the mailbox for the postal carrier; serve heart-shaped pancakes or eggs for breakfast (molds are easily found at baking stores); tuck in an "I love you" note in your child's lunch box with a sweet treat; send your mom a Valentine with a note saying, "Thank you for giving me the greatest gift—your love"; take a bubble bath and fill the bathroom with candlelight; or listen to love songs all day long.

We've all heard about Cupid, the Roman god of love. He was believed to enjoy spreading love and matching up couples who were meant to be. Today, he still lives in Valentine's Day celebrations and expressions all over the world. Perhaps you see him in illustrations on greeting cards (with his bow and arrow), or on the top of a box of chocolates, or printed on a pair of boxer shorts. You can bring Cupid into your love life by drawing a heart on the bathroom mirror with soap and filling it with the initials of you and your loved one, or write I LOVE YOU on a steamed-up window. Pen your loved one a poem and leave it on the steering wheel of his or her car (I'll bet you'll get an extra kiss when he or she gets home). Make a Valentine's Day card out of your favorite paper, or cut letters out of a magazine to spell out "I love you" in many languages. Here are a few to choose from:

Spanish: *Te amo*
French: *Je t'aime bien*
Italian: *Ti voglio bene*
German: *Ich liebe dich*

If you're planning on buying chocolates this year, add an artful touch by placing a love note under each chocolate in the box. Thoughts like "You make my heart smile," "Life's just better when we're together," "Thank you for being you," and, of course, "XOXO" will touch your loved one's heart and make the day and gift even sweeter.

Valentine's Day comes around only once a year, but you can keep love alive every day and all year long through the artful expressions you share with friends and family.

ust when I think winter will never end, the little buds on our forsythia trees begin to fill out. I love bringing the branches in and placing them in vases around the house, filled with warm water. Within a few days, I start to see little yellow flowers form along the branch, brightening the room and my spirits, reminding me that spring is nearly here.

Spring symbolizes rebirth, renewal, and reawakening. Even on gray days, purple violets pop through the last snow, white crocuses, yellow daffodils, and pink tulips reach toward the warming sun. The grass magically turns a shade of bright green, the buds on the trees start to form, and before long, cherry trees are ablaze with pink blossoms. The new warm air carries their sweet fragrance everywhere.

Easter often marks the beginning of spring, and eggs are the perfect symbol for the birth and fertility that abound. Decorate "eggstraordinary" Easter eggs with your family's pictures on them to make a beautiful centerpiece for your table. It's a simple project, but fun for everyone. First, print out photographs of all your family members from the computer (shrink each portrait to about the size of a quarter). After you've dyed the eggs a

color or combination of colors you love and allowed them to dry, cut the portrait out in a small circle (again, approximately the size of a quarter) and glue it to the egg. Use a ribbon, brightly colored pipe cleaners, or tinsel to frame and finish the photo around its edge. Fill a basket with shredded paper or grass, and arrange the portraits as a wonderful display of your "eggstra special" family.

On Easter one year, we invited some friends over for dinner, and the evening turned into an unexpectedly wonderful, wild, and wacky party. I filled the dining room table with Peeps (the little yellow marshmallow chicks), some feathers, ribbons, sequins, paper plates, pipe cleaners, paper, scissors, hot glue, buttons, and a bunch of beads and craft supplies. I invited everyone to play dress-up by dressing up his or her chick (Peep). Everyone had so much fun: some made hats and feather boas and created pearl necklaces. Others stuck feathers in the marshmallow to create a bouquet of colors, while one woman dressed her chick in a chic black-sequined evening gown. Once we finished dressing the Peep, we started dressing ourselves. We used paper plates as the base for a hat, made flowers from paper, glued buttons and beads onto the brims, and hung streamers with ribbon from them. Before we knew it, we were all sitting around the table each modeling an Easter bonnet "with all the frills upon it." We looked so lovely that we had our own Easter parade!

Whatever you do to celebrate spring, be sure to stop and take a look around. Take in the beautiful colors and fragrances that naturally fill our world. They will refresh you and give you energy to make healthy changes in your life—or to recommit to your life and loved ones with a renewed optimism and intention.

For several years, our daughter's friend Sarah invited us to her family seder, the celebration of **Passover**, which, like Easter, is a spring ritual celebrating freedom and rebirth. We gathered around a large table and our host began the seder with readings. One of the first questions the text asks is, "Why is this night different from all other nights?" The answer is that on this night we remember where we come from, what we have been through that makes us who we are. Our host would then explain the six parts of the seder plate, where we tasted bitter herbs, haroseth (a mix of apples, nuts, and honey), matzo, shank bone, and a hard-boiled egg, each of which symbolizes an experi-

ence of Jewish history. Friends and family gathered; they hugged, they kissed, they shared family news, and they laughed. We came to know that although our faith had some differences, we have many more similarities. And our response to the question "How is this night different from all other nights?" became, "We made new friends tonight."

Another friend shared her lovely tradition with me. At every seder, her husband goes around the table (as his father did), acknowledges each guest, and tells a story about him or her. He then acknowledges and gives thanks for the people who are not able to be present, or who have passed away. My friend loves this tradition, and everyone feels even more connected to each person at the table, and also reconnected to those who have passed on.

Women have always gotten together to work and talk. Today, we still assemble for many fun things, such as quilting bees, bridge, bingo, tea, lunch, and shopping. Whenever we gather, we share great power. When we come together, we change the world. The second Sunday in May is now celebrated as **Mother's Day**, a national holiday to give thanks to our moms. But did you know that Mother's Day was invented by Anna Jarvis in 1907 as a tribute to her mother, Anna Reeves Jarvis? Yes, Mother's Day was truly founded by a woman! In the 1850s, Anna Reeves Jarvis organized groups of women in West Virginia called Mothers' Work Day Clubs. These women provided medical and nursing care to the poor, inspected milk, and created shelters for children with tuberculosis. When the Civil War broke out, Mrs. Jarvis called together women's clubs from both sides of the war, asking them to work together to save the lives of all soldiers—their sons. Following the war, Mrs. Jarvis created Mothers' Friendship Days to bring families together who had been torn apart. In 1915, President Wilson honored her work by declaring the second Sunday in May as Mother's Day.

Julia Ward Howe, an abolitionist and author of "The Battle Hymn of the Republic," embraced the day and called on all women to make a statement following the outbreak of war in France and Germany. She wrote:

Why don't mothers of mankind interfere in these matters, to prevent the waste of human life of which they alone know and bear the cost? As men have often forsaken

the plough and the anvil at the summons of war, let women on this day leave the duties of hearth and home to set out in the work of peace.

Howe believed that although the world may be divided because of war and conflict, the experience of childbirth could bind together the mothers of the world. She hoped that the world could be united as one family.

Celebrate your own mother. Host a dinner or a brunch, and invite your brothers and sisters and their kids, too. Shower your mom with compliments and gifts fit for the queen that she is. A basket of bubble bath, soaps, and a gift certificate to a day spa will let her know you think she rules and deserves to be pampered. Write a poem that shares how much you care. Make a book and include a list of all the things you love about her and memories that you cherish. When my friend Linda learned the heartbreaking news that her mother had terminal cancer, she quickly realized that Mother's Day would now be every day that her mother was alive. The following is an excerpt of a letter she wrote to her mom.

Dearest Mom,

I thought you might want to know a few of the reasons I love you—past and present.

I love hearing your voice (nobody has it but you).

I love the way you always answered all of my questions as a kid.

And the way you cooked for us, always yummy, walking Leo before we woke up, and having breakfast and lunch ready before we went to school.

And the way you drove me everywhere.

And read to me.

And waited for me to come home from school, and listened to my day with interest.

And told Dad not to make me clean my room.

I love how you took me to Shoup Park.

And comforted me when it rained and we couldn't go.

I love how you tucked me in at night, every night.

And how you would come home late sometimes, and hug me with
 your fake, soft fur.
I love the way you ask for guidance, and admit you're not perfect.
And the way you are eating healthy foodstuffs and doing your affirmations.
I love the way you send Tosh little notes and packs of gum.
And, football and basketball Easter chocolates.
And how you write us letters beginning with "Dear Dolls."
And how you type labels on the tapes you send us.
I love how you save (and recycle) water and foil and plastic bags and paper towels.
And how you always have fresh flowers in the house, and roses in the garden.
And how you taught me to love planting things.
And, cooking and cleaning and mothering.
I love how you are such a good host at dinner parties.
And how you laugh at Dad's jokes, time and time again.
I love how you would wave at me from the front porch, or from the road,
 depending on how long I'd be gone.
And how you'd make me salad for breakfast.
And showed me how to get up each morning with a smile.
And taught me how to stay married and support my family.
And how to pray at night before bed.
And how to appreciate the rain with all my heart, putting all the indoor plants
 outside to have a drink.
I love how you'd shop at the funky health food stores (that are now all the rage).
And make lumpy carob-chip, oatmeal cookies that tasted better than
 the smooth kind.
I love how you were gracious when I dropped the Tisch from my name.
And how you acted goofy around Mark when you met him, like he was
 Robert Redford.
I love how your little nose gets tan in the sun.

And how you called me "Freckle Nose."

And how you helped me to love myself, knowing that whatever I did,
 my mom loved me.

Cause that's what you do best . . . love.

I hope you can love yourself as much as others love you.

Because the world is a much better place with you in it!

Those are a few of the things I love about you, but not all.

Words are never enough, ever.

<div align="right">

Forever,

Linda

</div>

Although Linda didn't have much more time to be with her mother, this poem helped her tell her mother what she wanted and needed her to know. You, too, can make a list of the things you love about your mother. It only takes a few short minutes to send a big message of appreciation and love.

A friend of mine made her mother business cards with remnants from her scrapbooking supplies. On the computer, she typed her mom's name and phone number, and for the job description, she wrote "Best mother in the universe." She printed the cards, and decorated each one uniquely with embellishments, stickers, and papers. Her mother loved the gift, and even more, she loved the thought and care behind it.

 few years ago, my sisters and I realized that none of the recipes for our favorite dishes had ever been written down. As Mother's Day was approaching, we decided that we would each make our favorite dish that Mom used to make for us when we were growing up. We held a Mother's Day brunch for her with all four generations of our family, and served the goodies of our childhood. We also decided to create a family cookbook. We hoped to pass along these family recipes with our memories to our children and from them to their children. Each of us sisters

created a page that included a recipe and a memory for the book. We all promised to add to the book at every family gathering. We add new recipes and new memories as we make them. Mom loved the buffet, and loved sharing the memories. She also loved not having to cook for an entire day (but, like all temperamental chefs, Mom said that some of our recipes needed her assistance). The day was scrumptious, and sweet memories floated in the air like the aroma of chicken and dumplings, grasshopper pie, and chocolate chip cookies.

Being a mother may well be one of the hardest, if not *the* hardest job on the planet. You only ever have one mom, so cherish her, let her know how much she means to you. Show her gratitude. Celebrate her and honor her with a day that says everything in a way that means I love you.

Right around the corner from Mother's Day is **Father's Day**. There are so many artful and fun ways to say how much you care about and love your dad. Think of all the things your father likes and create the day around him. Pay homage to your dad by making him breakfast in bed and letting him read the paper (uninterrupted) for a few hours. Host a cookout with the family and grill up his favorite meal. Frame a favorite picture of you and him together or spend a day with him on the golf course. If your dad likes to golf, paint "I Love You," "You're the Greatest," or "Best Dad" on a set of golf balls (or tennis balls, if that's his game) as a gift. If your dad is a gardener, give him a gift certificate to the local gardening store so he can stock up on annuals, perennials, and herbs for his garden. Better yet, go with him to the store and be his gardening assistant and get your hands dirty. Make a coupon book with IOUs and include things like:

Good for one car wash
Good for a movie and popcorn
Good for a lawn cutting
Good for a hug and a kiss
Good for a baseball game
Good for one backrub in front of the TV

Good for a day of no whining
Good for one day of doing whatever you want to do
Good for one batch of homemade chocolate chip cookies

Above all, enjoy the time you spend with your dad, and let him know how much you love and appreciate him.

John Adams, our second president, is credited with starting many traditions associated with the **Fourth of July**. Writing to his wife, Abigail, he said:

> *I believe that it will be celebrated by succeeding generations as the great anniversary festival. It ought to be celebrated by pomp and parade, with shows, guns, bells, bonfires, and illuminations from one end of this continent to the other.*

The American people took his call to heart. In 2005 alone, 161 million pounds of fireworks were set off, and some 66 million people participated in barbecues, while another 32 million more attended picnics.

On the Fourth of July, Independence Day, we celebrate the adoption of the Declaration of Independence in 1776. It is a day when Americans connect with and celebrate our freedom. Last summer, my family and I were visiting a small town in Maine on July Fourth. This little town held a big parade I will never forget. The local band (school kids and men and women of all ages ranging from six to ninety-six) played their instruments as men and women from all the branches of the military marched down the street. Each carried an American flag, and the crowd of locals and visitors alike clapped and waved their flags, hollering expressions of gratitude as their courageous fellow Americans walked past. The parade was a long stream of homemade floats, civic groups, tractors, antique cars, winning baseball teams, and community leaders, but mostly it represented a river of pride, belonging, gratitude, and a feeling of being connected to a country and to something bigger than ourselves.

This July Fourth, as you gather around the grill, take a moment to reflect on the hol-

iday, on what it is you love (or would like to improve) about America. Take stock of what you have, what you believe in, and value. This holiday offers parents an opportunity to teach and discuss with our children the ideals on which our country was founded. For older children, it is a great time to discuss current affairs.

Plan to see America. Take driving trips to the national parks, rivers, mountains, and glaciers. Visit places of historical significance: Williamsburg, Washington, D.C., Gettysburg, and Mount Vernon. Hang a map in the den or garage and place tacks showing where you and your family have traveled. If traveling is not in the budget this year, go online or rent movies about these and other wonderful places in our country. Make a list (or a collage) each year of places you'd like to see, and build these minivacations into your travel plans.

Have a barbecue for friends and family. Serve hamburgers and hot dogs, of course, and host a portrait contest—make potato heads of your favorite founding father using potatoes, carrots, kale, radishes, and other readily available veggies. Have everyone guess who is who, declare the portrait that looks most like a founding father contest winner! The award can be anything fun—a gift certificate for an ice-cream cone, movie passes, a bottle of wine (for grown-ups), or a book about the founding fathers.

Katharine Lee Bates wrote the words to one of my favorite songs, "America the Beautiful." Make a gift of this beautiful poem to give to each person at your picnic. Print the words on red paper, roll it up, and tie it with a blue-and-white-striped ribbon. The words will serve as a wonderful reminder of how important and valuable this precious land we call home is.

O beautiful for spacious skies,
For amber waves of grain,
For purple mountain majesties
Above the fruited plain!
America! America!
God shed his grace on thee

And crown thy good with brotherhood
From sea to shining sea!

I love the Fourth of July, with all of its parades, flags, music, and friends and family coming together to celebrate our country. In fact, I love it so much that twenty-five years ago I got married on this day! Every year, my husband and I celebrate our anniversary with friends and family, great food, and s'mores for dessert. And the evening of every anniversary, we see the sky fill with bright fireworks.

A friend of mine shared a special family story with me: for thirty-four years straight, her family has celebrated breaking the fast for the holiday of **Yom Kippur** with the same family. Her parents, the Solomons, started the tradition with the Kleins when each family had four young children. They would meet in the afternoon and count down the hours until they could break the fast together.

Over the years, the eight children married and had children of their own, and continue the tradition. They alternate houses—one year at the Kleins' house, one year at the Solomons' house. Everyone is assigned a dish to bring, and they almost never vary (it's mostly easy food and favorites, like bagels, cheese, macaroni and cheese, strawberries and cream, tuna salad, egg salad, and cake).

As sundown draws near, both families gather in the kitchen and begin to set out the food, which is always buffet style. At sundown, they all make up hearty portions and enjoy themselves. Because they haven't eaten all day, the food tastes even better than usual. They laugh. They eat. They take photos. And they laugh some more. The original ten-person gathering has grown to more than thirty attendees—babies, spouses, and anyone else they call "family." The kids of the kids have all become friends, and everyone looks forward to the consistency of the tradition. And heaven help the person who thinks about changing the menu!

Halloween may well be one of the most fun holidays of the year, and one that is already very artful. This holiday has everything: you can dress up, have a party, give treats, play

tricks, craft lots of decorations, create wonderful playful food, and listen to "bootiful" music.

Halloween is also a wonderful time to celebrate the fall. Bring the gorgeous fall colors inside with leaves. Collect leaves of every color (shades of orange, red, green, and brown) and glue them together to make a wreath for the front door. If you rake your leaves, be sure to jump in them before you put them in bags. Pour a glass of cold apple cider and taste the sweetness of fall.

A friend of mine loves the beautiful fall leaves so much that he used them to wallpaper his kitchen. He collected the leaves he loved (and removed the stems) and varnished them to a freshly painted wall, making a beautiful, lasting patina.

Our neighbors Marlene and Darlene have been creating a Halloween extravaganza for as long as I can remember. Both sisters have been the caregivers for many children in our town for years and years. As a way to bring together all the kids they have parented and still care for, they make a haunted house for the kids to come and enjoy. Young and old come by the carload every Halloween to see what the two sister witches (Marlene and Darlene) have conjured up. Each year they fill their front yard with lights, scarecrows, ghosts, and a graveyard, complete with a tomb for Boney Tony. They also play recordings of the sounds of ghosts and goblins singing in the cold dark night air. Not only do they decorate and plan scrumptious treats for all, they also put on a play of sorts. Each year, as we walk down the long black driveway toward their house and up the steps, we see scarecrows and ghosts along the way. We worry and wonder the whole time which one might just jump out and frighten us, because we never know which character the gals are playing. Our wonderful neighbors certainly put the happy in happy Halloween!

Decorate your pumpkins with character. Use fresh vegetables and toothpicks to fashion a face—a carrot for a nose, a cucumber slice or olives for the eyes, colorful corn or white garlic cloves for the teeth (you can glue them on), cut potato pieces for the ears, a little lettuce for the hair, and you've got the makings of a pumpkin with personality! Name these little guys and display them on your table, front porch, or on each step.

Halloween was made for candles. Illuminate everything. Carve large pumpkins for a

Whenever we gather, we share great power. When we come together, we change the world.

big scare, and use small pumpkins as candleholders. Scoop out the top with a melon baller to fit a taper candle. Turn the lights down low and fill the room with votive candles and taper candles of all sizes. You can even place an illuminated pumpkin in the fireplace for a fun, eerie glow.

Host a party and make ghoulish foods like deviled eyeballs, brains, and witch's brew. Deviled eyeballs are nothing more than deviled eggs with a green olive in the center for an eyeball with a small piece of pimento for the devilish red. Brains are easily concocted by scrambling eggs and adding some blue and yellow food coloring (the secret is in arranging them in the shape of an actual brain). And finally, for witch's brew you add some blue food coloring to lemonade. Bake a graveyard cake for all the ghosts and goblins in your life. Use your favorite cake mix (I like chocolate) and bake it in a nine-by-thirteen-inch pan. Ice it with chocolate frosting. Decorate the cake with crushed chocolate graham crackers for dirt, with gummy worms coming out of the icing and candy spiders and other bugs all over it. Slice marshmallows sideways to make gravestones to put the final touch on this spooky treat.

Dressing up for Halloween doesn't have to be difficult, expensive, or complicated. I have a standard way to approach costumes and dressing up for most occasions: it's called "just add black dress." A basic black dress can be the base for almost any occasion. For Halloween, I add black-and-white-striped stockings, a black boa, and a pointed black hat to become a stylish witch. To be a movie star, I use the same black dress, layer on pearls, a big fake diamond ring, a Marilyn Monroe–type blonde wig, stockings, high heels, and red lipstick, and I'm transported to the Hollywood of the 1950s. For a "purrfect" Halloween costume, I make a black tail and pin it to the back of my dress, glue two black felt ears onto a hair band, and draw little black whiskers below my nose that I've rouged slightly pink.

Halloween may sometimes be kooky and spooky, but it is always an opportunity to gather friends, family, witches, and angels for a party. Take lots of pictures—these moments will become cherished memories.

Of all the holidays, Thanksgiving is my favorite holiday! It's a day on which to acknowledge and express how grateful we are for what we have. It's a time to stop, honor,

and reflect on the abundance, prosperity, people, and lives we are blessed with. Friends and family gather to share delicious foods, wine, pumpkin pie, pecan pie, and sweet potato pie. This holiday calls for lots of cooking: turkey, duck, or ham, dressing, mashed potatoes, sweet potatoes, string beans, cauliflower, gravy, corn, cranberry sauce, and so on (depending on your family traditions and likes). It is a lot of work for one cook.

But one person does not have to be responsible for *everything*. Divide the menu among family and friends. The person hosting the dinner can bake or grill or deep-fry the turkey or ham, and everyone else can bring the rest. Make a list and a few phone calls to get the ball rolling. You'll love how easy, delicious, and stress-free the holiday can be when it is a group effort. The host can actually enjoy the guests, enjoy dinner, have a cup of coffee and a piece of pie, and be thankful she didn't have to do it all by herself.

Years ago, our friends were renovating an old house. When Thanksgiving rolled around, they were right in the middle of hanging the drywall and decided they had better keep working if they were to get the job done by Christmas. They decided they would be most thankful to get their house finished and to forgo the feast that year. My husband and I understood completely, having been through a renovation when we bought our home, but we decided we would surprise them with a little "construction" feast. We made a long candelabra out of a two-by-four to serve as the centerpiece on their workshop table. We drilled holes for white taper candles and glued pieces of brown corrugated cardboard to make a decorative vine motif. We roasted a small turkey breast, made a batch of stuffing, and opened a can of cranberry sauce. We loaded a picnic basket with paper plates, cups, plastic forks and knives, a bottle of wine, and a pumpkin pie we bought from a farm stand. Toward the end of the day, we headed over to their house and unloaded all the materials we needed to construct a little Thanksgiving dinner for them. Among the unfinished walls, subflooring, pipes, and wires, we shared what I think was one of the best Thanksgivings we ever had. Our friends were indeed thankful for a warm meal and some company in their new home.

Some families have a tradition of inviting each person to state what he or she is thankful for this year. It's a simple yet profound way to communicate with friends and

family, as we share what we each value and cherish. One year our family gave each guest a little book with his or her name on it. We then passed all the books around to everyone at the dinner table. Each person wrote at least one reason why he was thankful for the person whose name was on the cover. Guests laughed at first and said they couldn't think of anything to write. But then, as if by magic, each book became filled with heartfelt messages. When the evening was over, each person left with a book that said he or she is indeed special.

The truth about Thanksgiving is that it really doesn't matter what you eat, or where you gather, or what you wear. But it is important that you take a few moments for yourself to reflect and give thanks for what you have.

In English, there are at least sixteen ways to spell **Hanukkah**, including: Channuka, Channukah, Chanuka, Chanukah, Chanuko, Hannuka, Hannukah, Hanuka, Hanukah, Kanukkah, Khannuka, Khannukah, Khanuka, Khanukah, Khanukkah, and Xanuka. The literal translation means "dedication," but the word also shares the same root in Hebrew as "educate." Anyway you spell it, the meaning is still the same in our hearts. It is a wonderful Festival of Lights.

During Hanukkah, which lasts for eight days, candles shine to brighten the night, and family and friends gather to add warmth and their own light. The holiday is filled with tradition, delicious foods—including latkes (potato pancakes) and sufganiyot (doughnuts)—games, presents, songs, and the story of Judah Maccabee.

More than two thousand years ago, a Syrian king named Anitochus tried to force the Jews to give up their religion. Judah Maccabee led his people in a fight to drive the Syrians out of Israel. The Jews eventually won back the Holy Temple of Jerusalem. They embraced it, scrubbed and cleaned it, and polished the huge menorah. But when the rabbis were ready to begin services, they could only find a tiny jar of pure oil to burn in the menorah, only enough for one day. But by a miracle, the oil burned on and on for eight days.

Hanukkah is celebrated each year to share the story of that miracle and to rejoice in the Jewish faith. The menorah holds the candles that are lit throughout the eight days. Families pass down these important objects from generation to generation as heirlooms.

If you don't have an heirloom, you can visit a "make-your-own" pottery store and create your own family keepsake. Glaze and decorate a menorah for your children to light, or to give to a new couple just starting out. I promise this piece of art will be cherished by all those who use it, to fill their life with light.

Another temporary but fun way to make a menorah is to gather nine apples and then use a melon baller to scoop out a hole big enough to place a taper candle inside each one. Line up the apples in a row, and you have a beautiful natural centerpiece. Put other seasonal fruits or vegetables and leaves around it.

Make and send greeting cards from beautiful papers. Purchase blank cards and envelopes (in your favorite color), and cut eight pieces of paper to represent the eight days of Hanukkah. Glue them randomly on the front of the card, and then cut eight flames from white paper and glue them above the candles. Inside the card write, "Wishing you a season filled with light, love, and joy."

Because this holiday is all about light, make guests a party favor of a light. Glue pictures of each family or person onto small pillar candles with the message, "You make the world a brighter place."

Gather all the recipes for your favorite dishes and family secret recipes. Assemble a cookbook together with family photos to give to everyone next Hanukkah.

Take a family photo each Hanukkah, frame it, and display it with all the years before (and remember to leave room for all the years to come). The faces will change in the images, but the feeling of love and tradition will remain.

On each night of Hanukkah, the children receive a gift. You can start a new tradition by asking your child to donate a gift to another child who is in need. Teach your children to be openhearted and generous. Ask them to join you at a nursing home or a hospital, and spend the evening sharing time, playing with dreidels (spinning tops), and eating potato latkes with someone who is all alone.

Light up the world. When you invite families for Hanukkah, ask each to bring its favorite menorah. Have them light their own candles and fill every window and your home with light.

Simplify your celebrations, cooking, decorate gifts with focus on spending people

Seasonal

Share the together, create meaning, and time with the you love.

The **Christmas** season often becomes hectic, rushed, and exhausting as you pack the days with shopping, cooking, wrapping, decorating, and preparing for your family and friends. By the time your guests arrive, you are spent—emotionally, physically, and financially. Replace these unrealistic, disappointing, and stressful activities with the kind of holiday that you really want. Make a holiday that celebrates believing in magic, kindheartedness, and love. Create a Christmas that is thoughtful, relaxing, comforting, and satisfying. It's not about doing more, it's about doing what you do with meaning. You can add renewed warmth and sparkle to the season and surprise friends and family by getting creative this holiday season. When you keep in mind that the best gifts of the season are family and friends, you embrace the true spirit of the holidays.

As I traveled across the country last year visiting gift shows, craft shows, conferences, and stores, I asked many of the people I met to write a message on colorful heart-shaped paper to a soldier stationed in Iraq. People were eager and happy to participate. At the end of the year, the folks in my studio and I gathered all the messages from the heart and strung them on long pieces of brightly colored tinsel. We carefully packed them in a box and sent them to a unit in Iraq. We didn't know the American men and women who were serving in this battalion, but we knew we wanted to help make their holidays brighter, and to let them know that many folks around the country held them in their hearts and kept them in their prayers. You can also do this for any local reserve units on bases, or for the police and firefighters in your communities.

Instead of running all over town in search of that "perfect something," make someone something that is sure to please—a gift from the heart. Wrap chocolate bars with holiday greetings like "May your season be sweet," or "Merry Christmas from our home to yours." If the chocolate bar has nuts in it, you can write "We're nuts about you! Merry Christmas." Assemble a scrapbook and glue in your favorite family recipes and photos of past holidays. Decorate it with colored paper and ribbon. Give one to each family member; they will all cherish them. Create a festive wine label. Print out a picture of you and you family (the size of a wine label) and glue it on top of the existing one. On red colored paper write, "Cheers to you this holiday season" and attach with a piece of silver tinsel. Or make an "I

love you because" box and fill it with stars cut from shiny gold and silver paper, each bearing handwritten messages of reasons why you love them.

Sending holiday cards doesn't have to be a chore; you can make it downright fun by have a card-making party with the family. Make your own Christmas cards this year. Purchase a set of base cards and envelopes, and then invite your family to decorate them. You can just glue your family portrait on a red-and-white-striped background, or tie a red ribbon through the card and stamp the word *cheers* on it. For a more elaborate card, cut a Christmas tree shape out of green paper and have the kids decorate it with buttons, glitter, and beads. Each card will be an original, a one of a kind—a masterpiece (just like their creator). The time spent together will also be a treasure.

Get wrapped up in the holiday season. Use old newspapers, craft paper, or recycled brown bags from the grocery store as the base for your own beautifully festive wrapping creations. Wrap the package in the "basic" base paper, add beautiful colored ribbon, tie on an ornament, or make a gift tag from a photo of the person for whom the gift is intended. Colorful shredded paper makes a beautiful bow when tied to the top of the box with tinsel or ribbon. Or you can use strips of expensive gift paper as a decorative narrow band framing the center of the package on top of the recycled paper as the base. These beautiful, creative packages are fun to make and a wonderful gift to give.

Look for gift tags in nature—adorn your packages with holly, evergreen pieces, berries, poinsettias, and pinecones. Create gift tags with clever verses that relate to the gift inside. If you're giving a candle, for instance, you might write "You make the season sparkle and shine." And if the package is a jar of homemade jam, write "Wishing you a 'berry' nice holiday."

Host an ornament-making party. Invite friends over and ask them not to bring gifts, but to be prepared to make one. Fill bowls with beads, ribbons, notions, cut-out cardboard shapes like stars and hearts, colored wire, glue guns and glue sticks, glitter, and buttons. Ask your guests to make an ornament using the materials you supplied. Gift wrap the completed ornaments in white paper and tie with a ribbon. Pass around the ornaments among all the guests in a game of "hot potato." You can sing Christmas carols while playing. When

the song is over, stop passing the packages. Each person will end up with a gift made by someone else at the party. Your guests can take the gift home as a party favor to hang on the tree (or somewhere special), as a reminder of the time spent with family and friends.

Imagine the possibilities. Ornaments add color and the spirit of the season to place settings for holiday brunches, desserts, and gala gatherings. Use them as napkin rings, or name-card holders. Tuck several ornaments into your mantelpiece decor, or hang them from garlands draped over your fireplace or doorway. Hang an ornament from the rearview mirror of your car. "Deck the car with boughs of holly, fa-la-la-la-la, la-la-la-la." Have fun as you discover the secret life of ornaments.

Tie an ornament with a brightly colored ribbon around the outside of pillar candles. This added touch makes them sparkle and shine even brighter. Go beyond fruit and berries, and use large and small ball ornaments to decorate a wreath. Personalize them with the names of each family member with a gold permanent marker. String together small glittery round ornaments with silver and gold beads to make a fun and festive necklace for the season.

Load up the car with friends and family and Christmas cookies for a drive through your town or city to see all the amazing and outrageous lights and decorations your neighbors have created. You can learn a lot about the folks in your town through their colorful expressions of holiday spirit. Maya Angelou expressed this best when she said, "I've learned that you can tell a lot about a person by the way he/she handles these three things: a rainy day, lost luggage, and tangled Christmas tree lights."

implify your seasonal celebrations, share the cooking, decorate together, create gifts with meaning, and focus on spending time with the people you love. Stay in or go out, make it a big deal or make it nothing at all. Do what expresses you, not what you think you *have* to do. Above all, celebrate what matters most—your friends and family.

Artful Ideas for the holidays

FOR NEW YEAR'S EVE

A New Year's resolution is something that goes in one year and out the other.

- Create "Memory Keepers": instead of making resolutions, have friends and family write their thoughts about the old year and their hopes for the new one. Place all the notes in a bottle or glass jar. Make a decorative label for the year, and put it away for a year. Next New Year's Eve, break it open and read the thoughts and wishes aloud. Then make another version to be opened the following year.

- Invite friends and family over for a pajama party, and watch the ball drop in Times Square from the comfort of your family room. Tell everyone to bring his or her sleeping bag and pillows—no designated drivers will be needed. Everyone can help make a big breakfast of pancakes, sausage, frittata, and mimosas the next morning.

- Clean house. Write down a list of all the things you'd like to be free of—bad habits, negative thoughts, troubling events from the recent past, *anything*—and place it in the fireplace (or light the grill outside if you don't have a fireplace). Burn them up to warm both your home and heart.

- Enjoy a southern tradition—cook up a hearty pot of black-eyed peas or Hoppin' John on New Year's Day. Not only are they considered to be good luck (turnip greens and cabbage are said to bring an abundance of money with that good luck), but they're a healthy, delicious way to welcome in the new.

- Bring out the video camera each year and get in the habit of starting a "January First" video diary of your family. You will be amazed to see how much you've all grown and changed, and how much has happened. Ask each member of the family for a recap of his or her year, especially highlighting the "wins." (Whenever you have five or ten years saved up, create master tapes for everyone's video collection.)

- Make your own fortune cookies and pass them around just before midnight.

FOR VALENTINE'S DAY

> Love doesn't make the world go round. Love makes the ride worthwhile.
> —Franklin P. Jones

- Make a CD of your loved one's favorite songs, including a few of your own favorite love songs. Make a paper valentine for the CD label, with the message "You make my heart sing."

- Bake sugar cookies in the shape of hearts and sprinkle with red hots, red-colored sugar, and red M&M's.

- Plan to bake a heart-shaped cake for the special day, and surprise your loved ones with it for breakfast. Wrap in tinfoil little pieces of paper with the reasons why you love your family so much, and bake them into the cake. Enjoy watching as your family has fun discovering the expressions of love. Eat cake for breakfast at least one day a year. You'll love it!

- Send your beloved a singing telegram. Or be your beloved's singing telegram.
- Help some children make nostalgic, fun valentines with a Victorian appeal for their friends, grandparents, and teachers. Buy red construction paper and heart-shaped paper doilies. Cut the red paper in the shape of the heart (a bit bigger than the doily) and glue the pieces together. You can adorn the hearts with school pictures, stickers, and glitter, or photos from magazines of people, cupids, birds, and flowers.

FOR EASTER

'Twas Easter-Sunday. The full-blossomed trees filled all the air with fragrance and with joy.
— Henry Wadsworth Longfellow

- Plant bright yellow daffodil bulbs in pots indoors a few weeks before Easter so they are in full bloom as the dinner-table centerpiece.
- Decorate chocolate eggs and bars with personalized name messages for place-card holders and fun party favors. Write the message or name on pastel colored paper and wrap it around the chocolate or egg like a label; fix it with a piece of clear tape.
- Fill the house with branches from the newly blooming dogwood, apple, forsythia, or magnolia trees in the yard or neighborhood.
- Instead of the traditional Easter egg hunt, have the kids hunt for bottles of bubbles, and have them fill the air with magic as they find each one.
- Decorate your table with nests (bought at the craft store) filled with brightly dyed eggs.
- Plant wheatgrass in long tin containers a couple of weeks before Easter so they sprout to create a perfect bed for decorated eggs. This makes a fun centerpiece or a wonderful decoration for the mantelpiece.

- Create unique Easter baskets out of tin buckets, small wooden berry crates from the grocer, or terra-cotta garden pots.
- Invite friends and family for brunch, and ask each person to bring a favorite spring dish. Enjoy a stress-free day with everyone.
- Fill your home with spiritual music for the morning—hymns, chants, bells, or choir music.

FOR MOTHER'S DAY

> All I am I owe to my mother.
> —George Washington

- Create a recipe book with your family's favorite dishes.
- Write a poem for Mom.
- Make a book, with the help of your siblings, titled *You Are the Best Mother in the Universe.* Ask sisters and brothers, even cousins and other relatives, to give you a list of the things they most respect, love, and admire about your mother. Fill the book with these thoughts and treasured photographs.
- Bring Mom breakfast in bed with her favorite food and drink. Place a flower in a small vase, next to a little book of poetry and a note that reads "I have a superhero in my life. I call her Mom."
- "Momnap" your mom and take her out for an adventure to a museum, a day at a spa, an art gallery, a show, an outdoor garden—something she would love, and something that will surprise her.
- Say no to your mother. No cleaning, no cooking, no running errands, no work of any kind—*no kidding!* Make this day her day to relax, play, unwind, and feel adored.

FOR THE FOURTH OF JULY

My countrymen, know one another, and you will love one another.
—Lucius Q. C. Lamar, U.S. House of Representatives,
April 27, 1874.

- Throw an all-American barbecue. Ask your guests to come dressed in red, white, and blue. Decorate the table in the same color scheme and make the centerpiece a bouquet of red, white, and blue flowers. Serve simple hamburgers, hot dogs, potato salad, and deviled eggs. Stick a miniflag into each hot dog and hamburger bun!

- Serve cheesecake (or a white sheet cake) decorated with blueberries and strawberries (placed strategically to look like the American flag). And of course, you must have apple pie!

- Organize a neighborhood parade and decorate pets and bicycles.

- Read a biography of a founding father of the United States—try a new one each year.

- Hang a large flag from the front of your house.

- Send a care package to a serviceman or -woman overseas, with a little note of thanks for his or her hard work on behalf of our country.

FOR HALLOWEEN

Witching you a bootiful Halloween

- Visit a real pumpkin patch and pick your very own—of several sizes—from a field full of orange.

- Don't just decorate pumpkins. Use acorn and butternut squash, cucumbers, onions,

and gourds. Attach buttons, marabou, ribbon, and beads to these veggies to make funny fall creatures.

- Make caramel apples, then roll the gooey apple in pieces of M&M's, nuts, and chocolate chips to make delicious treats.
- Decorate your front porch with spooky glowing pumpkins and spiderwebs (made from old cassette tapes or black yarn).
- Host a pumpkin hunt for the kids. Hide mini pumpkins around the yard as you would Easter eggs. The child who finds the most pumpkins gets—what else—more treats!!
- Make ghostly party favors by using lollipops and a white napkin. Drape the white cocktail napkin over the ball of the lollipop and twist a bow with a black pipe cleaner to secure. Glue on two black dots for eyes, and you have a seasonal favor.
- For a ghoulish treat, fill small clear candy bags with Hershey kisses and gummy spiders and snakes, and tie the bag closed with a bright orange ribbon. For a tag, write "Witching you bugs and hisses this Happy Halloween," and attach to the package with the ribbon.

FOR THANKSGIVING

Thank you for the sky so blue, thank you for the green grass, too. Thank you for the birds that sing; thank you, Lord, for everything.
—My favorite childhood prayer

- Order a carryout dinner or buy prepared foods at your grocer's. Spend time with your guests, not with the turkey (unless of course your friends are turkeys)!
- Donate time at a soup kitchen or shelter. You'll serve up a warm meal and receive an even warmer feeling in your heart.

- Invite someone to your home for dinner who would otherwise be alone.
- Make a pie or bread that you are famous for. My aunt Grace makes the most delicious walnut cake. I am always thankful for it, and for her!
- Not in the mood for a crowd? Pack a picnic and head outdoors. Enjoy the crisp fall air, the countryside, and the company.
- Bake cookies in the shape of fall leaves (molds readily found at bake shops or online) and invite all the kids (adults, too!) to decorate in orange, red, and green icing. Sprinkle colored sugar on top for a beautiful sparkling treat.
- Send a thank-you note to your teacher, a friend, or a coworker, saying how much you appreciate having him or her in your life.
- I'll never outgrow making a picture of a turkey by tracing my hand and coloring in the silhouette to resemble a big gobbler. Instead of fancy linens this Thanksgiving, cover the table with brown craft paper and invite your guests to create a tablecloth of these hand turkeys. Provide the crayons and the inspiration, and let your guests create the artful tablecloth.

FOR HANUKKAH

Shalom
—Hebrew word for peace

- Ask everyone to write who (and what) fills his or her world with light. Place it in a box to be opened next Hanukkah.
- Use candles everywhere for decoration—after all, this is the Festival of Lights. Decorate your walkway or front porch with luminaries cut from paper bags. Cut holes, hearts, or stars in the bag, and fill the bottom with sand before placing a small votive candle inside.

- Wrap Hanukkah gifts in white paper that you have stamped with silver words like *light, love, joy,* and *peace.* Tie a bow with silver tinsel ribbon.
- Make a videotape of all your guests as they say, "Happy Hanukkah." Play it at next year's celebration for a look back at years past. Add to the tape each year. It will become a treasured document of (and for) the people who matter most.
- Fill a basket with applesauce and latkes and take to the local senior community center. Drop in a few pieces of chocolate gelt (gold coins).
- Make a Hanukkah surprise grab bag. Each person brings a gift under five dollars and drops it in the bag. Throughout the evening, everyone gets to pick a surprise!
- Invite someone over who doesn't celebrate the holiday, or who might not have family in town. Share your family and traditions with him or her.
- Make sugar cookies in the shape of dreidels and invite all the kids to decorate with icing, blue sprinkles, and silver candied balls.

FOR CHRISTMAS

Christmas, children, is not a date. It is a state of mind.
—Mary Ellen Chase

- Have a cookie-baking party. Supply ingredients and make cookies with your friends to give as gifts.
- Create a breakfast tradition for your family, and repeat it each year: banana-nut pancakes, cinnamon French toast, or crepes. Make something that warms the heart and the tummy.
- Adopt a charity or cause and give a gift that helps it succeed in its mission.

- Donate gifts to a family in need. Make a Christmas dinner and deliver it to a family less fortunate than yours. Local churches often have a list of families that need a helping hand and a giving heart.
- When it's time to trim the tree, play carols, serve cookies, and make it a party. Do the same thing when it's time to put the tree and the trimmings away. Turn a chore into a pleasure. It's all in how you see it.
- Instead of placing gifts in the stockings, put clues in the stockings about where the gifts are. Have the kids (or adults) go on a treasure hunt Christmas morning.
- Purchase puzzles, card games, and craft kits as gifts that you can have fun doing with the kids. You can even have your family photo made into a puzzle.
- Have a gift-making day with your kids and family. Knit a bright red scarf for Grandma (this only takes a few hours), turn old CD cases into frames that work as coasters, make personal stationery by cutting a special someone's initials from magazines, or using a stamp on colored prebought stationery. Teach your children and remind yourself that when it comes to giving, it really is the thought that counts.
- Three weeks before the holiday season, plant paper white narcissus bulbs in big terra-cotta pots. Plant and water so they will be in full bloom, and their sweet fragrance will waft throughout the house. As the tall shoots begin to sway, tie them together with silver tinsel for a festive look.

you make the WORLD a better place

Making Your Mark on the World

I want to tell you about a very special person in my life. Her name was Dr. Margret Zassenhaus, and she was my hero—not only because of her uncommon courage, but also because of her unvarying kindness.

Dr. Zassenhaus was our family physician. I remember days when Mom would squeeze all five of us girls into the car to visit the doctor. We looked forward to visiting her, as she happily greeted us at the door with her thick German accent and ushered us through her waiting room and into her office. Our visits always went well until the smell of cookies came wafting through the air. Once we began to smell the cookies, one of my sisters would begin to cry, then another and another, and before long, all of us would be in tears. The doctor's mother would come into the office with a plate loaded with warm freshly baked cookies. You see, Dr. Zassenhaus, in her gentle and kindhearted way, had asked her mom (who lived with her above the office) to bake us a treat on the day of our vaccine shots— a reward for what we would endure. But my sisters and I had come to know the routine, and although we *loved* the cookies, we knew that that smell meant . . . *the shot*!

Margret's compassion also manifested in every large and small action—in the way she extended her friendship, joined community boards, cared for patients, and listened to them. She shared stories of the people who inspired her, like Albert Schweitzer and Mahatma Gandhi, and taught us that every human being matters; that even the smallest gesture could affect the world in a constructive way. I first heard the famous Gandhi charge, "You must be the change you wish to see in the world," in her voice, as well as Schweitzer's message: "Constant kindness can accomplish much. As the sun makes the ice melt, kindness causes misunderstanding, mistrust, and hostility to evaporate."

Margret was gentle and kind, but she was also courageous. Born in Germany, she was

under the rule of Adolph Hitler during World War II. As a young medical student assigned by the Gestapo to monitor Norwegian and Danish political prisoners, she took it upon herself to smuggle in medicines, carry out letters, and ultimately save many lives. After the war, Margret learned that her mother, too, had been part of the Resistance, although neither of them had confided in each other about their involvement during the war, so as to protect one another if the worst happened and they were to be found out.

When I was a girl, I asked her, "Were you scared when you saved the lives of all those men?" and she replied, "Of course, I was very scared! But I was the only one in a position to help, so I did what I could do." I have come to learn that that is all any of us can do.

A basic, wonderful truth about all people is that through our choices and actions, we can and do make the world a better place. We don't have to do huge things to make a big difference. Even the smallest kindness has the power to resonate through this sometimes difficult and troubled world. The loving actions we share make miracles happen. Willa Cather wrote, "Where there is great love there are always miracles." The greatest miracle workers are disguised as mothers, fathers, grandparents, neighbors, sisters, friends, daughters, nurses, teachers, and volunteers.

> There are only two ways to live your life. One is as if nothing is a miracle. The other is as though everything is a miracle.
> —Albert Einstein

Individual acts of kindness and generosity of spirit change the world. Kindness is magical, contagious. A single smile brings on another smile; a good morning invites another greeting. Thoughtfulness, consideration, and care enhance our well-being and others', too. Civility and respect are the foundation for any relationship to begin and grow.

Without kindness in our lives, our world can quickly turn cold, empty, and negative.

Kindness gives us hope, it connects us to each other, and it reminds us of the beauty that lives in each of us.

Being kind requires only a desire to contribute to the world in a positive way. Simple acts of kindness and generosity of spirit require little effort, yet they touch our lives deeply and have a huge effect. We have all had days where nothing seems to go right, yet then, out of the blue, someone holds open a door, yields so you can pull your car out on a busy street, or says, "You look pretty today!" These simple actions change a negative moment into a positive one.

One of my favorite quotes is by Henry James: "Three things in human life are important: one is to be kind, the second is to be kind, and the third is to be kind." When we are shown kindness, we feel we belong, we feel connected, we feel that we matter.

Allow the inspirational stories in this chapter to remind you of the many ordinary people who have accomplished extraordinary things because they wanted to make a difference (and believed they could). Look around and recognize friends, family members, and neighbors who transform the world by their acts of thoughtfulness, compassion, and care. Celebrate your own purposeful actions, as you participate in your home, schools, communities, towns, states, country, and the world. Your positive, creative responses to social issues matter—they and you can change the world for the better.

There is great power in living consciously, with the goal of celebrating and helping one another. The smallest of efforts can yield positive results.

I learned long ago that those who are the happiest are those who do the most for others.

—Booker T. Washington

I recently read about a wonderful woman who lives in Salt Lake City, Utah. Having been homebound while battling lymphoma, she felt lonely and in need of someone to talk with. She reasoned that there must also be other lonely people stuck inside without com-

Even the
smallest kindness
has the power
to resonate
through
this difficult
and sometimes
troubled world.

panionship. She called the county senior services and asked them to help her reach out to other seniors who might want to chat on the phone, have someone check up on them, or simply get a call to say hello. Shortly after her inquiry, they gave her the name and number of another woman who needed just such a thing. What began as a single call and a lone volunteer, has grown into a program called The Life Care Bank, with 350 volunteer callers, and even more people at the other end of the line.

Following the devastation of Hurricane Katrina—one of the worst natural disasters in our country's history—a group of people in San Francisco began "The Blanket Project." Their mission is very simple: to let those directly affected know that Americans across the country are concerned about them. The Blanket Project reminds us that the making of blankets and quilts is a time-honored tradition in which love and care are stitched into an object that gives warmth, comfort, and shelter. The Blanket Project envisions every survivor of Katrina enveloped in blankets sewn with wishes, prayers, love, and support. This grassroots effort invites each of us to make a quilt or blanket to cover someone in kindness. Hundreds of blankets have been made and shipped to the Gulf Coast, and thousands more are being made. Children are making them in schools; women are making them at book clubs; and families are making them at home. Anyone can make a blanket, even *you*.

One woman had a friend who saved her family, but lost everything else—her house, job, and lifestyle—in the storm. Wanting to help her, she went through all her own photographs, finding many pictures of the woman and her family taken over the years. She gathered them in a book—a treasured memento to share. Her gift was an act of kindness that helped soothe her friend's aching heart.

Covering someone in love is a common practice. In another national program called Project Linus, women lovingly craft handmade mittens, blankets, hats, gloves, and scarves that are donated to local hospitals and schools to be given to children in need. The ladies in this group are "blanketeers," who provide love, a sense of security, warmth, and comfort to children of all ages who are very ill, or otherwise in need of a lovingly made gift.

There is no end to the many ways in which people can reach out to help others. Our friend Marty participates in the annual Polar Bear Plunge. Men and women dive into the

Chesapeake Bay when the water temperature is a freezing thirty-two degrees to raise money for Maryland's Special Olympics. As supporters each year, we are sent a hilarious picture of Marty freezing his rear off. In spite of the really uncomfortable temperature, he is always smiling, as he "dives for dollars."

The artist Barbara Dale rounded up her friends and started crafting handmade bears. Called "Dale Bears," each is fashioned primarily from donated clothes, jewelry, and other castoffs. Then it is given a name and a story. For example, an old dishtowel from Santa Fe becomes a bear named Tucson, who sports a feather necklace and turquoise earrings (and makes pottery in her spare time). These stuffed animals for grown-ups are "beary cute," and since all the proceeds from the sales of the bears go to a nonprofit group—The House of Ruth, whose mission is to end domestic violence—they make a difference in the lives of many women. Barbara says: "Many of the people we serve have limited assets—no money, no home, no support network. They are survivors. They teach us about human transformation, as they achieve so much with so little. By creating bears out of dishtowels and scraps, we mirror, and honor, that transformation."

I recently learned about a group of women and girls who have named themselves GEM (and all the girls are gems!), and are collecting shampoos, soap, and miscellaneous personal-care items (you know, all those bottles we collect from hotels and motels) to make basic self-care bags for women who are being sheltered from abusive husbands and boyfriends.

A story of the power we possess when people work together recently brought me to tears. *CBS Evening News* covered a human chain made up of thirty people who were rescuing five beachgoers from a riptide in Bloomington Point Beach, P.E.I. The five swimmers were enjoying the afternoon in the water when suddenly the rip yanked their footing our from under them and pulled them quickly and without warning into deep water. The swimmers could have drowned, but bystanders linked their arms, formed a long line, and after nearly an hour, managed to pull every one of them to safety. Strangers and friends pulled together, connected arm by arm, and found the strength to rescue all those people. Imagine a world where this loving, thoughtful, intuitive, innovative, and powerful force was used to solve all of our problems.

"Three things are important: kind, the second and the third

in human life
one is to be
is to be kind,
is to be kind."

Henry James

> Remember, if you ever need a helping hand, you'll find one at the end of your arm . . . As you grow older you will discover that you have two hands. One for helping yourself, the other for helping others.
>
> —Audrey Hepburn

My friend Maureen was ready to retire, but didn't want to stop working. She wanted to do work that mattered, that made a difference, so she started an organization called "Our Journey." Asking friends and family to give what they could, she raised enough money to travel to and live in South Africa for a year while working in an orphanage with babies with AIDS or HIV. Most of the little ones are without parents, and most are without hope. Maureen provides both parenting and optimism to those precious children. Her online journal connects her to friends and supporters, helping to keep us on "our journey" together.

> I don't think you ever stop giving. I really don't. I think it's an ongoing process. And it's not just about being able to write a check. It's being able to touch somebody's life.
>
> —Oprah Winfrey

Creative acts that positively affect our society happen all the time, everywhere—from Rosa Parks, who stood for what she believed in by sitting down on a bus, to Osceola McCarty, a cleaning woman who, over the course of her lifetime, saved and eventually donated $150,000 to the University of Mississippi for a scholarship program. Miss McCarty, who left school in sixth grade, said, "I want to help somebody's child go to college." Her act of kindness touched the hearts of people all over the world and inspired

others to give. Genesio Mortacci left $2.3 million to a small university in Great Falls, Montana, after having spent his life working as a janitor and dry cleaner. He had a passion for education and tending his roses and tomatoes. He was quoted as saying, "If you don't need it, you shouldn't buy it." He thought kids needed an education, though, because his gift has purchased it for many for many years.

The American Visionary Art Museum in Baltimore, Maryland, is a treasure that celebrates and educates its visitors on the power of the creative spirit. The museum's founder and director, Rebecca Hoffberger (a visionary in her own right), has created an entire wing to showcase people whose creative acts of social justice have touched many lives. That building is named after James Rouse, whose visionary ideas helped to flame renewal and development of cities across the country. His philosophy is expressed clearly in this quote: "For many years, I have lived uncomfortably with the belief that most planning and architectural design suffers for lack of real and basic purpose. The ultimate purpose, it seems to me, must be the improvement of mankind." He's gone now, but his visionary approach to urban development helped to plant the seeds of change, and the ideas that our cities and towns ought to be places where people can grow.

The museum displays works by people who have no formal training in the arts, but have an innate desire to express and to share their unique perception of the world. Ester Nisenthal Krinitz, at the age of fifty, began creating thirty-six magnificent needlework and fabric collages depicting how she survived the Holocaust. Meticulously stitched, these works of art narrate a young girl's terrifying experience and her will to live. Ester never dreamed they would be exhibited, having only created them for her two daughters. Gerald Hawke created magnificent sculptures by gluing thousands of single matchsticks together. Gerald believed that each person is like one matchstick—capable of providing light—but that when people work together, their light becomes most powerful, bright, and brilliant.

Stories, images, and art fill the interior and the exterior of this museum with the power of the human spirit. It is not a static holding place for objects, but a living museum that encourages creativity, self-expression, and action. Over the past several

years, the museum has hosted a mentoring program with kids from the local high school. The students worked with a master ceramicist and mosaic artist to completely cover the outside of the museum in beautiful cobalt-blue glass pieces, shards of discarded pottery, and broken mirrors. The walls symbolize the beauty that can be seen in all things, even discarded, broken objects. The lesson is reflected on the walls for all to see: when we value potential in things and in people, they will come to value it in themselves.

The educational goals of the American Visionary Art Museum are a call for creative action that each of us can apply to our own lives.

1. Expand the definition of a worthwhile life.
2. Engender respect for and delight in the gifts of others.
3. Increase awareness of the wide variety of choices available for all, particularly students.
4. Encourage each individual to build upon his or her own special knowledge and inner strengths.
5. Promote the use of innate intelligence, intuition, self-exploration, and creative self-reliance.
6. Confirm the greatest hunger for finding out just what each of us can do best, in our own voice, at any age.
7. Empower the individual to choose to do that thing really, really well.

Wangari Muta Maathai plants trees. In 1977, she planted nine trees in her backyard in Kenya and founded the Green Belt movement. She planted the trees to stop soil erosion and provide wood for cooking fires. She has been arrested, imprisoned, and beaten for her efforts, and she has also won the Nobel Peace Prize. Wangari has organized more than a hundred thousand women in Kenya and surrounding countries to plant thirty million trees, *so far.* One tree at a time, these women are planting for a brighter future for themselves, their descendants, and their country.

Believe that you can make a difference and you will.

ometimes cities can touch their residents in artful and healing ways, too. When eighteen-year-old Tiffany Grant lost her life in a car accident at an intersection in downtown Baltimore, her mother simply could not go near the place, as it increased her feeling of pain and loss. But something unexpected changed that. The city erected a red-and-white street sign that read "Tiffany Grant Way." The sign helped ease the mother's pain a little, and she was thankful. Talking about the 180 signs that have been placed on city streets over the past twenty years, a city spokesman explained, "The signs are intended to honor special individuals, places, and events that have affected Baltimore's communities." This one honors the memory of a young woman who was a friend, an honor student, and a daughter.

Sadly, in many parts of America, funding for art and music classes has been cut, leaving kids who express their voices without words few opportunities for self-discovery and development. Yet all over the country, people and organizations recognize the healing properties of creativity and the arts, and are doing something about it. In New York, an organization called Free Arts mentors kids through the experience of painting murals and making sculptures, fostering their self-discovery. A mentor and volunteer wrote to Free Arts, describing what the experience has meant to her:

It truly is the wonderful feeling of being inspired which keeps me returning and giving my time. I can't be the only one whose work world is all about generating profit, meeting deadlines, turning out product, getting things done. Then I take the subway uptown, immerse myself in the work with the kids and Free Arts, and I think, Aha! This is what the world is really about. It's all about connecting with others, nurturing young people, building community, feeling like you can make a difference, and participating in something greater than oneself. It's good to be reminded about what really matters. I may show up feeling tired or down, but I leave feeling happy and spiritually nourished. My experiences as a Free Arts Weekly Mentor provide an invaluable sense of balance, perspective, and meaning that spills over into the rest of my life.

We all have the power to make a difference in others' lives. Through our intention and actions, we choose to bring positive experiences into our lives and make them for others. We can all do something. Do what you can. Do what looks like it needs doing. Do it your own way. Do it because you want to. Do something because you know you can.

Be a mentor. Teach someone to read. Sit awhile with someone who is lonely. Volunteer. Serve food at a shelter. Make art with kids. Compliment someone. Listen to what someone has to say. Visit a friend who is sick. Wave to the women sitting in the window at a nursing home. Tell someone you are thinking about her. Be a role model. Work with Habitat for Humanity to build a house. Lend a hand at the local fire hall. Use your money generously. Walk for what you believe in—peace, breast cancer research, life. Comfort someone when he is sad. Walk your neighbor's dog. Participate in a food drive. Bake something or buy something from a bake sale. Clean your closet and donate the clothes you don't wear.

Every once in a while you hear something that you know in your heart is true. This statement by the anthropologist Margaret Mead is one of those things, and a reminder, I believe, of something very important—the power that lives in each of us:

> Never doubt that a small group of thoughtful people can make a difference, in fact it is the only thing that ever has.

Giving of ourselves is the only way we can change the world, and in doing so, we change ourselves for the better. Forever.

giving of

only way we

the world, and

we change

the better.

ourselves is the

can change

in doing so,

ourselves for

Forever.

the heart of living

ARtfuLLy

ten principles

hope you've come to recognize within the pages of this book that life is a work of art, and you are the artist of your life. Living Artfully will enrich not only your life, but the lives of your family and friends, your neighborhood, your town, and beyond. Remember, you are one of a kind, an original. There is no one just like you. Confidently embrace life with your own genuine style, knowing that you have the power to create meaningful moments that matter.

There is purpose and beauty in each thought, action, choice, and gesture you make. Play, laugh, dance, care, understand, have patience, try, imagine, create, invent, dream, and love—for these are the tools that you paint your life with. Every moment is an opportunity to live fully, openly, and with heart. If you

follow your heart, and act on the desire to connect, to belong, and to love, you will make a meaningful difference in the world, and *your world will be filled with happiness and meaning.*

What one can do to affect the quality of the day, that is the highest of the arts.

—Henry David Thoreau

As this book comes to a close, I invite you to open a dialogue with me and share the many ways you live artfully. I would love to hear and pass on your stories, ideas, and suggestions of the things you do to embrace and celebrate the artful life. No act is too small, from the way you tuck your child into bed each night to the ways you document your family history. Write to me and share how you wrap a gift, make a special cake, host Thanksgiving dinner, say happy birthday, decorate your home with salvaged architectural pieces, create fund-raising festivals for your local charity, plant a garden of fragrant flowers for your grandmother, or keep your Christmas tree up all year to remind you about the magic that lives in the everyday. Please visit our website, SandraMagsamen.com, to discover more artful suggestions, and to share your own!

I'd love to hear from you! Please send your ideas and stories to:

Sandra Magsamen
P.O. Box 5013
Glen Arm, MD 21057

Be you. Living Artfully is expressing who you are and celebrating the people in your life through the objects and the moments that you create. Stop censoring your actions. Be you, the only you there is. No one else is qualified for the job. Have fun, identify and embrace what you love, define what you believe in, dream. Be the person you are meant to be.

Act on the desire to connect, to belong, to love and be loved. You are driven to communicate. Your desire to communicate is innate—a shared, basic human need. Follow your heart, act on the desire to connect, to belong, and to love, and you will make a difference in the world, and *your world will be filled with happiness and meaning.* Living Artfully nourishes your spirit. It is a force that can transform your life.

Come to your senses. Use your whole self as you engage in the world each day. Engage your senses, they are your most valued resource for living creatively. Far too often we ignore our senses: we eat dinner on the run, not tasting the flavors. We don't see the wildflowers growing on the side of the road as we scurry to our destination. Remember, the joy of the journey is in the ride. Slow down and see, taste, touch, and hear life.

Expand the definition of creativity to include all aspects of living. To be human is to be creative. Your creativity lives in your heart and mind every moment of every day. You have the power to summon it anytime you like. Let creativity become as much a part of the fabric of your daily life as are your everyday routines, like making the bed, cooking meals, cleaning the house, and caring for the people you love. Fill these everyday, seemingly mundane tasks with spirit, individuality, fun, and life.

Cultivate and use your own language. Ultimately, to find happiness, you must find your own unique way to express yourself. As your personal language develops, so, too, does your creative nature. You have your own style and an abundance of creativity to express and share. Do things your way; make choices that reflect your beliefs, purpose, and aesthetic. Bake, write, paint, sew, talk, work, dance, plant, or hug. No act of Living Artfully is "too small." Every gesture or word you use to communicate love and caring will

resonate and multiply. Through your creative personal language, you can communicate important messages that you cannot convey by words alone.

Create moments that matter. Every moment is an opportunity to live fully, openly, and with heart. You have the power to create meaningful moments that matter, to bring beauty into being. Fill the moment with ideas, values, beliefs, purpose, people, and actions that define who you are.

See the beauty in everything. When you focus on what is right, lovely, and beautiful, you are Living Artfully. Look for the positive, the opportunity, the good in people, ideas, experiences, and places. The way you look at life is the way it will be. When you see what is beautiful in someone, she, too, has the opportunity to see it in herself. When people feel valued they add value to relationships, life, and the world. When you see the beauty in a place or situation, you imbue it with a renewed purpose and enrich it with meaning. It's a beautiful thing!

Play. Play more, smile more, laugh more. Play rejuvenates and revitalizes you. It helps you see the world from different points of view. It rekindles your optimism, encourages experimentation, invites laughter, and renews your ability to be flexible and resilient and make meaningful connections as you adapt to the changing world.

Imagine the possibilities. There are *no* rules. Life is a work of art and you are its artist, born with the tools to create anything you can imagine. Living Artfully is recognizing and embracing your own gifts of imagination, curiosity, and playfulness—and *having fun!*

Live life passionately. Embrace each day as if it were the last. Follow your heart and dream big. Live consciously and enthusiastically with your focus on what you can bring to the moment. Life is precious. Each heartbeat is a gift. Allow care, compassion, empathy, understanding, forgiveness, generosity, and kindness to guide your decisions, actions, and life.

Acknowledgments

hen I began talking to my friends and colleagues about the idea of *Living Artfully*, I made and gave a ceramic plaque inscribed with one of my favorite quotes by the anthropologist Margaret Meade. It read, "Never doubt that a small group of thoughtful, committed people can change the world, in fact it is the only thing that ever has."

As the project grew, this quote became the mission for those who joined the journey. Day after day as the book grew from a thought, to an outline, to a proposal, to chapters, to an illustrated four-color book, thoughtful and committed people joined the team. Each person brought an abundance of talent, ideas, imagination, belief, kindness, the ability to impart knowledge, the desire to make a difference, and the hope to share a way of living that honors every life as a work of art.

It is with great pride and gratitude that I have collaborated with so many lovely, wonderful people in the creation of this book. I thank them with all my heart.

I am blessed to have a family who is "there" through the good times, the bad times, and every time in between. My husband, Mark Barry, and my daughter, Hannah, who enrich every day with endless amounts of art, love, fun, beauty, joy, and laughter.

My Mom, who taught her girls to drink from the glass half full and told us with conviction, "you can be anything and everything you want to be," and we believed her. Granny, whose favorite color is still red and even at ninety-eight years young continues to passionately embrace life. My sisters Donna and Lisa, who are always there for me. My sister Karen who is "my everything." Thank you for diving headfirst into your creative well this year, learning Photoshop to lay out this book, brainstorming ideas for products, and managing the business of the business. I could not do without you. My

twin sister, Susan, whose friendship nurtures and supports me. It is a beautiful thing to have someone in my life who sees and lives in the world through similar eyes and heart. My dad, whom I love.

Billie Holiday got it right when she said, "Without friends, I ain't got nothing." Thank you, my dear friend Rebecca Hoffberger, whose belief in me is unwavering and who teaches me daily to have faith in the power of the things we cannot see. Rebecca is a living example that love is a mighty force that can move mountains, fund a museum, and make the world a better place. The museum she founded, The American Visionary Arts Museum, inspires the spirit, uplifts and validates the belief that each person is a gift bringing value, beauty, and meaning to the planet. Valerie Sanson, who just gets it, gets me, gets life, and lives it with a passion. Her style, grace, kindness, and je ne sais quoi are a delightful present to all those who meet her.

Trina Storfer and Susan Miller, who started this journey eight years ago as my licensing agents and who have, to my great delight and appreciation, become cherished advisors and trusted friends.

Sandi Mendelson and Richard Heller, who bring an expertise in public relations and law but equally impart an abundance of kindness, guidance, understanding, and belief in me. I cherish them and their commitment to our work.

Richard Pine, literary agent extraordinaire, whose sharp focus of what is important and meaningful has patiently and with good humor guided me through the publishing of this book.

Leslie Meredith, my editor and collaborator at Free Press. From our first meeting Leslie graciously shared herself, her creativity, her ideas, and her love for living an artful life. What a gift it has been for me to have had the opportunity to work and play with Leslie.

Dominick Anfuso and Martha Levin, who from day one got behind this project and generously gave it loving care and attention so that it could grow within Free Press.

Suzanne Donahue, Carisa Hays, Emily Santos, and Jill Siegel, who generously embraced this book and brought their unique talents and selves to this project as they made the most artful and wonderful plans for sales, marketing, publicity, and promotion.

Eric Fuentecilla, Dana Sloan, and Ted Landry, for making the cover and each page and each word beautiful.

Deborah Jensen, for "tweaking" so many pages of ideas. Thank you for reading my words with your eyes and your heart.

Bill Tonneli, whose ability to listen, excavate, organize, and write helped me to create a proposal that spoke to the heart of *Living Artfully*.

Linda Sivertsen was an unexpected gift to me and to this project. Not only does she understand what it means to live artfully, but she does so with great beauty, heart, and care. I cherish the hours spent talking through content, sharing stories, reciting quotes, learning where to place a comma and a semicolon, and above all creating a new friendship.

I believe that through our loving choices, thoughtful decisions, and creative actions we can and do make a positive difference in the lives of others. My life has forever been enriched by the folks who have helped to make this book. It is my hope that together we have changed the world for the better, one heart at a time.

Life is
your canvas—
no one can
paint it
but you!